FRANCIS FRITH'S

ST AUSTELL BAY

PHOTOGRAPHIC MEMORIES

PETER STANIER was born in Liskeard and has written a number of books and papers on Cornish subjects, in particular mining and quarrying, as well as Francis Frith's *Cornwall Living Memories, Victorian and Edwardian Cornwall, Churches of East Cornwall, Photographic Memories of Britain: Cornwall, St Austell* and *Newquay to St Ives*. He lives with his family in Shaftesbury, Dorset, where he is a lecturer and writer on archaeology, industrial archaeology and landscapes.

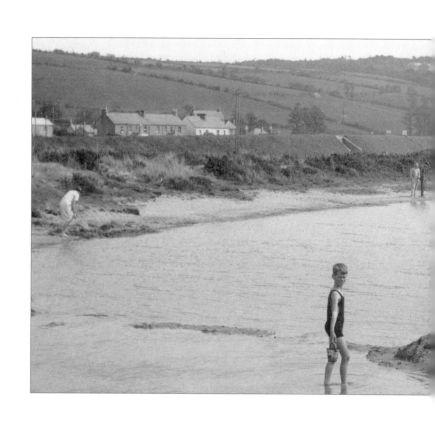

FRANCIS FRITH'S
PHOTOGRAPHIC MEMORIES

ST AUSTELL BAY

PHOTOGRAPHIC MEMORIES

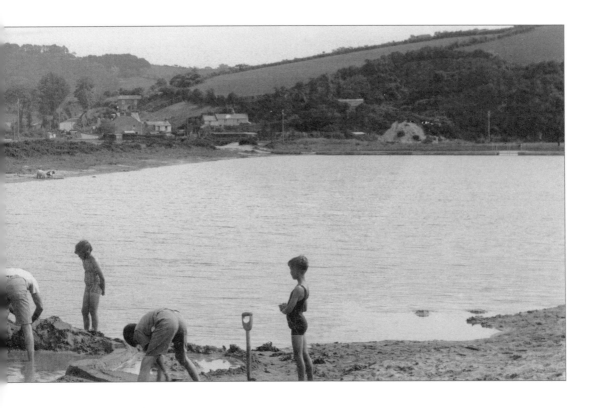

PETER STANIER

First published in the United Kingdom in 2004 by
Frith Book Company Ltd

Limited Hardback Subscribers Edition Published in 2004
ISBN 1-85937-820-X

Paperback Edition 2004
ISBN 1-85937-821-8

Reprinted in Paperback 2005

British Library Cataloguing in Publication Data

Francis Frith's St Austell Bay - Photographic Memories
Peter Stanier

Frith Book Company Ltd
Frith's Barn, Teffont,
Salisbury, Wiltshire SP3 5QP
Tel: +44 (0) 1722 716 376
Email: info@francisfrith.co.uk
www.francisfrith.co.uk

Printed and bound in Great Britain

Front Cover: **PORTHPEAN**, *The Beach c1955* P87005t
Frontispiece: **PAR**, *Children's Pool 1938* 88577

*The colour-tinting is for illustrative purposes only, and is not intended
to be historically accurate*

AS WITH ANY HISTORICAL DATABASE THE FRITH ARCHIVE IS
CONSTANTLY BEING CORRECTED AND IMPROVED AND THE
PUBLISHERS WOULD WELCOME INFORMATION ON OMISSIONS OR
INACCURACIES

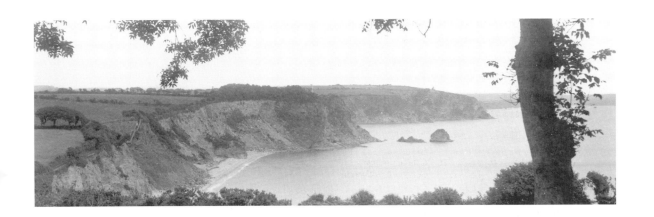

CONTENTS

FRANCIS FRITH
VICTORIAN PIONEER

FRANCIS FRITH, founder of the world-famous photographic archive, was a complex and multi-talented man. A devout Quaker and a highly successful Victorian businessman, he was philosophical by nature and pioneering in outlook.

By 1855 he had already established a wholesale grocery business in Liverpool, and sold it for the astonishing sum of £200,000, which is the equivalent today of over £15,000,000. Now a very rich man, he was able to indulge his passion for travel. As a child he had pored over travel books written by early explorers, and his fancy and imagination had been stirred by family holidays to the sublime mountain regions of Wales and Scotland. 'What lands of spirit-stirring and enriching scenes and places!' he had written. He was to return to these scenes of grandeur in later years to 'recapture the thousands of vivid and tender memories', but with a different purpose. Now in his thirties, and captivated by the new science of photography, Frith set out on a series of pioneering journeys up the Nile and to the Near East that occupied him from 1856 until 1860.

INTRIGUE AND EXPLORATION

These far-flung journeys were packed with intrigue and adventure. In his life story, written when he was sixty-three, Frith tells of being held captive by bandits, and of fighting 'an awful midnight battle to the very point of surrender with a deadly pack of hungry, wild dogs'. Wearing flowing Arab costume, Frith arrived at Akaba by camel sixty years before Lawrence of Arabia, where he encountered 'desert princes and rival sheikhs, blazing with jewel-hilted swords'.

He was the first photographer to venture beyond the sixth cataract of the Nile. Africa was still the mysterious 'Dark Continent', and Stanley and Livingstone's historic meeting was a decade into the future. The conditions for picture taking confound belief. He laboured for hours in his wicker dark-room in the sweltering heat of the desert, while the volatile chemicals fizzed dangerously in their trays. Back in London he exhibited his photographs and was 'rapturously cheered' by members of the Royal Society. His reputation as a photographer was made overnight.

VENTURE OF A LIFE-TIME

Characteristically, Frith quickly spotted the opportunity to create a new business as a specialist publisher of photographs. He lived in an era of immense and sometimes violent change.

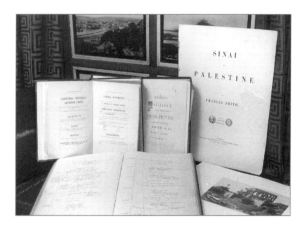

For the poor in the early part of Victoria's reign work was exhausting and the hours long, and people had precious little free time to enjoy themselves. Most had no transport other than a cart or gig at their disposal, and rarely travelled far beyond the boundaries of their own town or village. However, by the 1870s the railways had threaded their way across the country, and Bank Holidays and half-day Saturdays had been made obligatory by Act of Parliament. All of a sudden the working man and his family were able to enjoy days out and see a little more of the world.

With typical business acumen, Francis Frith foresaw that these new tourists would enjoy having souvenirs to commemorate their days out. In 1860 he married Mary Ann Rosling and set out on a new career: his aim was to photograph every city, town and village in Britain. For the next thirty years he travelled the country by train and by pony and trap, producing fine photographs of seaside resorts and beauty spots that were keenly bought by millions of Victorians. These prints were painstakingly pasted into family albums and pored over during the dark nights of winter, rekindling precious memories of summer excursions.

THE RISE OF FRITH & CO

Frith's studio was soon supplying retail shops all over the country. To meet the demand he gathered about him a small team of photographers, and published the work of independent artist-photographers of the calibre of Roger Fenton and Francis Bedford. In order to gain some understanding of the scale of Frith's business one only has to look at the catalogue issued by Frith & Co in 1886: it runs to some 670 pages, listing not only many thousands of views of the British Isles but also many photographs of most European countries, and China, Japan, the USA and Canada - note the sample page shown on page 9 from the hand-written Frith & Co ledgers recording the pictures. By 1890 Frith had created the greatest specialist photographic publishing company in the world, with over 2,000 sales outlets - more than the combined number that Boots and WH Smith have today! The picture on the next page shows the Frith & Co display board at Ingleton in the Yorkshire Dales (left of window). Beautifully constructed with a mahogany frame and gilt inserts, it could display up to a dozen local scenes.

POSTCARD BONANZA

The ever-popular holiday postcard we know today took many years to develop. In 1870 the Post Office issued the first plain cards, with a pre-printed stamp on one face. In 1894 they allowed other publishers' cards to be sent through the mail with an attached adhesive halfpenny stamp. Demand grew rapidly, and in 1895 a new size of postcard was permitted called the court card, but there was little room for illustration. In 1899, a year after Frith's death, a new card measuring 5.5 x 3.5 inches became the standard format, but it was not until 1902 that the divided back came into being, so that the address and message could be on one face and a full-size illustration on the other. Frith & Co were in the vanguard of postcard development: Frith's sons Eustace and Cyril continued their father's monumental task, expanding the number of views offered to the public and recording more and more places in Britain, as the


5						
6	.	St Catherine's College		+		
7	.	Senate House & Library	+	+		
8			+	+		
9	.	Gerrard Hostel Bridge	+	+	+	+
3 0	.	Geological Museum		+		
1	.	Addenbrooke's Hospital		+		
2	.	St Mary's Church		+		
3	.	Fitzwilliam Museum, Pitt Press &c		+		
4				+		
5	Buxton, The Crescent				+	
6	"	The Colonnade			+	
7	"	Public Gardens			+	
8						
9	Haddon Hall, View from the Terrace				+	
4 0	Millers Dale				+	

coasts and countryside were opened up to mass travel.

Francis Frith had died in 1898 at his villa in Cannes, his great project still growing. The archive he created continued in business for another seventy years. By 1970 it contained over a third of a million pictures showing 7,000 British towns and villages.

FRANCIS FRITH'S LEGACY

Frith's legacy to us today is of immense significance and value, for the magnificent archive of evocative photographs he created provides a unique record of change in the cities, towns and villages throughout Britain over a century and more. Frith and his fellow studio photographers revisited locations many times down the years to update their views, compiling for us an enthralling and colourful pageant of British life and character.

We are fortunate that Frith was dedicated to recording the minutiae of everyday life. For it is this sheer wealth of visual data, the painstaking chronicle of changes in dress, transport, street layouts, buildings, housing, engineering and landscape that captivates us so much today. His remarkable images offer us a powerful link with the past and with the lives of our ancestors.

THE VALUE OF THE ARCHIVE TODAY

Computers have now made it possible for Frith's many thousands of images to be accessed almost instantly. Frith's images are increasingly used as visual resources, by social historians, by researchers into genealogy and ancestry, by architects and town planners, and by teachers involved in local history projects.

In addition, the archive offers every one of us an opportunity to examine the places where we and our families have lived and worked down the years. Highly successful in Frith's own era, the archive is now, a century and more on, entering a new phase of popularity. Historians consider the Francis Frith Collection to be of prime national importance. It is the only archive of its kind remaining in private ownership. Francis Frith's archive is now housed in an historic timber barn in the beautiful village of Teffont in Wiltshire. Its founder would not recognize the archive office as it is today. In place of the many thousands of dusty boxes containing glass plate negatives and an all-pervading odour of photographic chemicals, there are now ranks of computer screens. He would be amazed to watch his images travelling round the world at unimaginable speeds through internet lines.

The archive's future is both bright and exciting. Francis Frith, with his unshakeable belief in making photographs available to the greatest number of people, would undoubtedly approve of what is being done today with his lifetime's work. His photographs depicting our shared past are now bringing pleasure and enlightenment to millions around the world a century and more after his death.

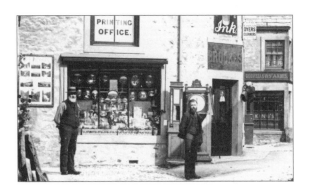

ST AUSTELL BAY
AN INTRODUCTION

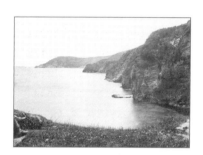

FRANCIS FRITH'S photographs in this selection were taken in and around St Austell Bay on the south Cornish coast over the period from the 1880s to the mid-1960s. We see coastal scenes with cliffs, coves and beaches; the fishing harbours at Polkerris and Mevagissey; and the china clay ports of Par, Charlestown and Pentewan. There are also photographs of towns and village communities, especially of St Austell, which gives its name to the bay, along with street scenes at St Blazey, Par Green and Polgooth, where we are also shown examples of churches and chapels. Industry looms large in the form of the china clay workings to the north of St Austell, with other industries such as mining and railways around St Blazey and Par.

St Austell Bay was formerly known as Tywardreath Bay, and it has also been known as Polkerris or Par Bay. It lies between the Gribbin Head and Black Head, although for this book we

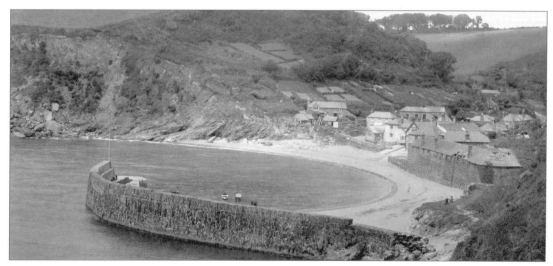

POLKERRIS, *The Old Quay c1950* P65004

continue around Black Head to include Mevagissey Bay - this may be said to be an extension of the greater bay as far as Chapel Point. The photographs have been arranged as a coastal tour working around the bay westwards from the Gribbin Head; we turn aside briefly to look at St Austell, and finish at Mevagissey.

The Gribbin Head guards the eastern side of the bay, and is identifiable by the red and white striped daymark built by Trinity House as an aid to shipping in 1832. It was designed to help ships' masters to distinguish the bay from Falmouth harbour and as a guide to the where-abouts of Fowey. The closest we get to the Gribbin is a view from Polridmouth Beach, which is actually on the Fowey side of the Gribbin and outside St Austell Bay. The Gribbin (and most of the other cliffs) is made of slates and shales, which are often prone to crumbling and slipping into the sea or onto the beach, but dolerite, a hard igneous rock, is exposed at Black Head on the far side of the bay. Black Head has an Iron Age cliff castle or promontory fort, one of similar defensive earthworks found on Cornish headlands (the nearest is a very large one at Dodman Point).

There are accessible beaches and coves, such as the one at Porthpean, and hidden ones too at Polgwyn Beach near Black Head or Apple Tree Mine Beach near Charlestown. Larger beaches, however, have resulted from the accumulation of waste from mines and china clay workings. This is best seen at Polmear and Par, where the whole area was once a large estuary. The sea reached inland past Tywardreath and St Blazey to Treesmill and Ponts Mill as recently as the late 18th century, and travellers could cross the narrows at Par by means of a ferry at high tide. All this was changed beyond recognition during the industrial revolution. Waste carried down the Par stream from mines, tin stream works and the china clay pits filled in the estuary, and sand banks were deposited out into the bay; here milky clay-clouded water could still be seen well into the 20th century. Much of the beach at Crinnis or Carlyon Bay is also artificial, but it protects the cliffs from erosion by the sea. Pentewan's beach grew rapidly seawards because of the material brought down its river – the beach eventually cut off the harbour.

Apart from the coast, the area offers some fascinating scenery in the Luxulyan valley, where steep wooded slopes with protruding granite blocks are to some extent enhanced by the viaduct, but the vegetation is now much more grown up since our photograph. Nearer the coast, we are shown the tiny hidden valley of Trenarren and the longer Pentewan valley, both also sheltered havens for trees.

It is pleasing to see Mevagissey, which is one of Cornwall's best-known 'picture postcard' fishing harbours, and much loved by visitors. It had a small pier in the mid-15th century before the harbour was enlarged with two piers in the 1770s. A harbour extension was only a year old when it was destroyed during the great blizzard of 1891; it was replaced in 1897 by the present outer piers, which include a pierhead lighthouse. Fishing boats were built here, and the local craft (known as toshers) worked with drift nets and long lines. Although the boats have changed, Mevagissey continues to be a lively working port today. In contrast, the delightful little hamlet of Polkerris nestling in a coombe at

the edge of the bay has hardly altered over the years. This is borne out in the selection of photographs taken between 1880 and 1965. A pier was built here by the Rashleighs of Menabilly in about 1735 for sheltering a fishing fleet, but the boats had gone by the time of the first photograph. A fish-curing cellar (or 'palace') at the back of the beach is said to be one of the largest in the county. The photographs show this abandoned building's roof gradually deteriorating and losing its slates over the years. A few small open fishing boats are seen drawn up on the beach at Porthpean. There is another fish cellar here in the photographs, although its site now forms a dinghy park.

St Austell Bay had three commercial ports, each fascinating in its own way. Charlestown was built between 1791 and 1801, and was named after its promoter, Charles Rashleigh. It was cut out of the cliffs at West Polmear as a floating dock with a lock gate to allow ships to stay afloat at all tides. Copper ores were exported from here, but china clay became the main export in later years, being tipped down chutes into the ships. Imports included coal and staves for the barrels used to hold china clay. We are treated to several views showing subtle changes to details around the dock and in the types of ships. The dock is packed with sailing ships in 1885 and 1904, but in the 1950s motor coasters are the common sight here. The arrival or departure of these little ships through the twisting outer harbour was always a popular attraction. Today, Charlestown is a centre for historic sailing ships and film makers.

The port of Pentewan was the child of Sir Christopher Hawkins; it became an outlet for ores and china clay after a railway was built from St Austell in 1829. As at Charlestown, a floating basin was protected by a lock gate, but Pentewan had an ongoing battle to clear the entrance of the sand and silt brought down by the river from the china clay district; there were good reasons why the St Austell River was called the 'White River'. Trade fell off after the Pentewan Railway closed in 1918, and the harbour basin became isolated and disused.

Industrial developments at Par in the 19th century were closely associated with the activities of Joseph Treffry. He built a tidal harbour behind a breakwater in the 1830s for exporting minerals, granite and china clay - the imports included coal and timber. Industries around the harbour included a silver and lead smelting works, a stone-dressing yard, a candle factory and, later, a flour mill. The tall chimney for removing the poisonous fumes from Treffry's smelting works was a major landmark, and the 'Par Stack' was reckoned to have been 280ft high before it was felled in 1907. Limeburning was another coastal industry, where the limestone and fuel were brought in by sea to harbours or beaches for burning. There are rare pictures of the kilns at Porthpean and Charlestown, and a more distant view of the one at Polkerris. Among the old mines of the district, we get a few sightings of Par Consols, which was a rich producer of copper ore and tin in the mid-19th century. It was conveniently placed for the harbour.

No study of the St Austell area would be complete without reference to the china clay pits. 'Sky tips' of white sand waste formed the characteristic landscape of the 'Cornish Alps' commanding St Austell Bay, from which they were

also visible to shipping. We see good examples of tips at Lower Ninestones pit, although this type has been superseded by less attractive modern methods of tipping. Carclaze pit was famous as a tin working before it turned to clay. One of the Charlestown photographs shows the characteristic long 'dry' to which its clay was piped; the smoking chimneys of other drys appear incidentally around St Blazey.

The Cornwall Minerals Railway built an impressive engineering works at St Blazey; there is also a photograph of its station on the Newquay branch line. Further inland, the great viaduct and aqueduct over the Luxulyan valley is another reminder of the enterprising Treffry. The main line of the Great Western Railway is seen several times around Par, and a brand-new viaduct on the west side of St Austell is one of many late-19th century replacements for Brunel's original Cornish viaducts. Steam was still the only means of locomotion in the mid-1950s, when the most recent railway photograph shows the Cornish Rivera Express near St Austell, appropriately passing close to the Cornish Riviera Club.

St Austell is the main town in the district, where we see the busy Fore Street over the years with a number of familiar household names on the shop fronts. A selection of photographs allows comparisons to be made in the street scenes at Par Green. In St Blazey itself we see the Palace Cinema housed in the old town hall, which has since closed – it has been converted into flats. The Pentewan Valley, with its road and railway along the bottom, was a lifeline between the sea and St Austell. Polgooth is an old mining village lying off the valley, and it was photographed when it was a quiet backwater

shortly before it saw a greater housing expansion. All the street scenes are remarkably free of traffic. The towns and villages were well provided with places of worship. St Austell's parish church is one of the finest in Cornwall - the carvings on its tower are especially notable - while St Blazey's is somewhat humbler. For comparison, Victorian churches and chapels are much in evidence at Par Green, Porthpean, Pentewan and Polgooth.

And so to more secular pleasures. St Austell is not far from the sea, and Porthpean's beach, literally just down the road, became popular for day trips from the town. The Glen Private Boarding and Lodging House was built here in 1889, where 'visitors to this charming seaside resort will find at this house every attention given at moderate charges.' Excellent bathing, boating and fishing were noted in the 1920s, when pleasure steamers from Fowey and Looe called on certain days in the summer months. At Par Sands we see beach huts and holidaymakers enjoying the sands in the traditional way. Camping and caravan parks became increasingly popular during the 20th century, and developments are just beginning at Pentewan in the 1930s - the Pentewan Sands Holiday Park now covers much of this open ground. More comfortable surroundings for holidays were provided in the 1930s with the building of a smart hotel on an open site near a golf course before Carlyon Bay grew into a residential area. Down on the beach below, the Cornish Riviera Club provided entertainment and sports facilities. The cliff top beside the Carlyon Bay Hotel gives sweeping views across the whole of the bay which is the subject of our photographs.

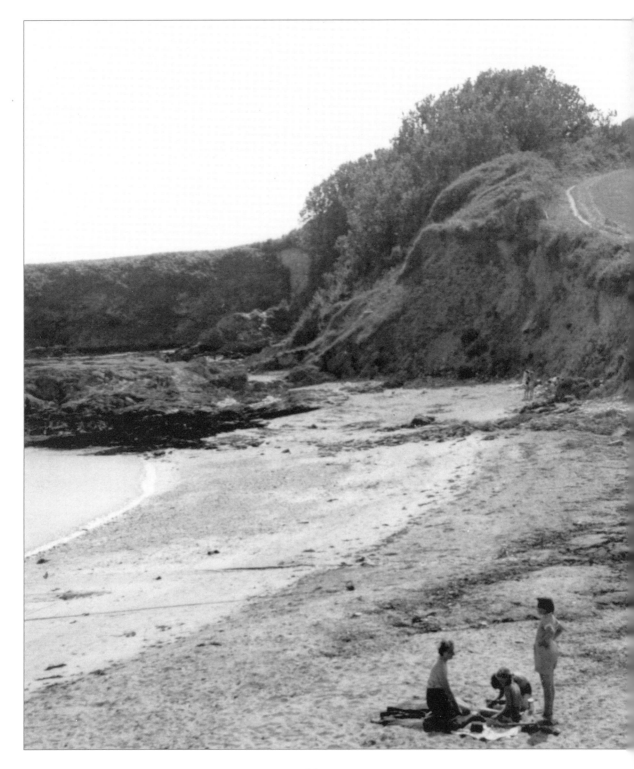

POLKERRIS

POLKERRIS
Polridmouth Beach near Gribbin Head c1960
P65037

This scene has hardly changed for many years; the beach at Polridmouth is still only accessible on foot. Although we are just around the corner from St Austell Bay, this photograph gives us a good view of the prominent day mark erected in 1832 on the Gribbin Head as an aid for shipping entering the bay.

▼ POLKERRIS *1888* 21260

A boat sails across the bay, which was known as Polkerris or Par Bay in the late-18th century. The little village of Polkerris is situated at the end of a sheltered valley on the east shore of St Austell Bay. There was an important pilchard fishery here, and the pier (left) was built in about 1735 for sheltering the fishing boats rather than for trade.

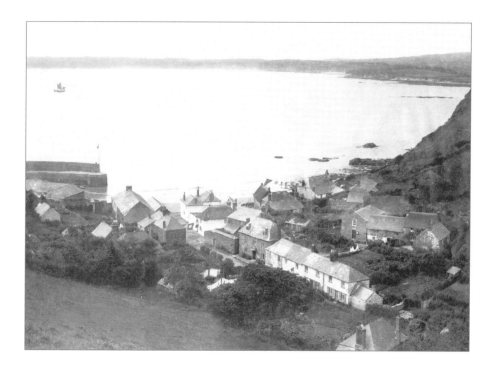

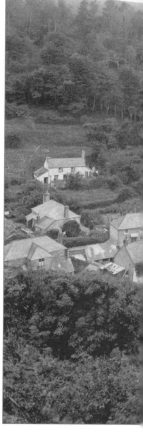

► POLKERRIS
1888 21261

The old pilchard-curing cellar, or 'palace', beside the shore in the foreground was one of the largest in Cornwall. However, by the time of this early photograph the harbour seems already deserted by the fishing fleet, perhaps in favour of Mevagissey on the far side of the bay.

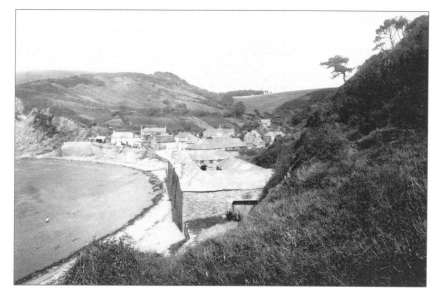

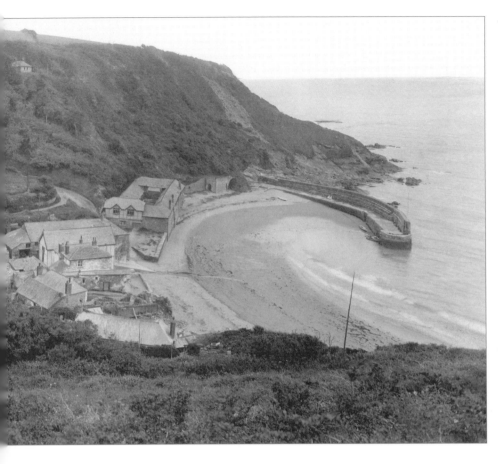

◄ **POLKERRIS**
1927 79885

The old limekiln stands on the beach between the curving pier and the fish palace. Limestone was shipped in from Plymouth and burnt with Welsh culm (anthracite) to make lime, which was taken by local farmers to neutralise their acid soils. Many Cornish harbours and creeks had similar kilns.

► **POLKERRIS**
c1950 P65001

Polkerris has hardly changed, with virtually no new houses in 70 years. Here we see the village tucked away in its valley, with the great expanse of the bay reaching beyond to Black Head (centre) and the Dodman Point (left). The garden plots of the houses are prominent, sheltered by hedges and mostly on the south-facing slope on the right.

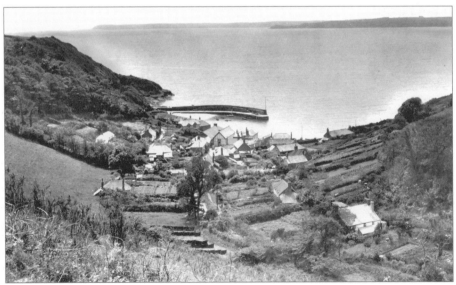

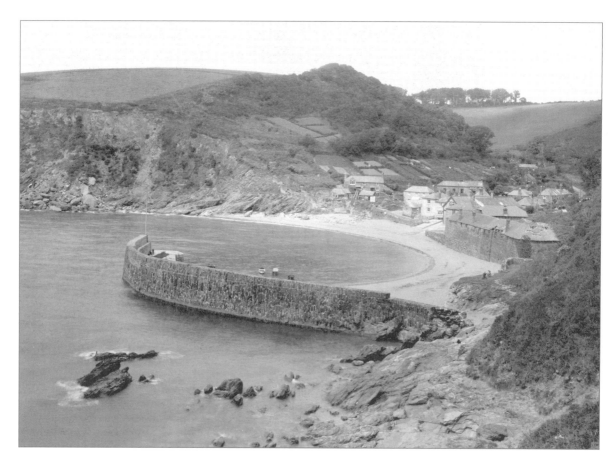

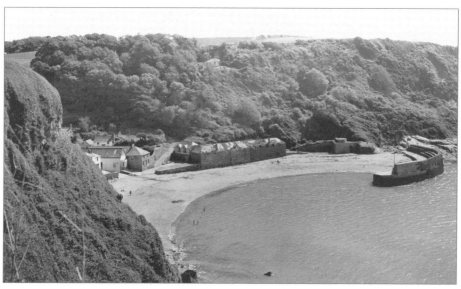

◄ **POLKERRIS**
The Harbour
c1960 P65031

By this date the fish palace is falling into decay and is losing the slates from its roof. To its left we can see the old lifeboat house and slipway.

◄ POLKERRIS
The Old Quay
c1950 P65004

The curving pier has been well maintained, although it serves just a handful of small boats. There has been erosion by the sea on the far side of the cove, for the high defensive wall and at least one cottage seen in 1888 (21261, page 16) have disappeared. Garden plots flourish on the slope above the village, and the woodland has matured too.

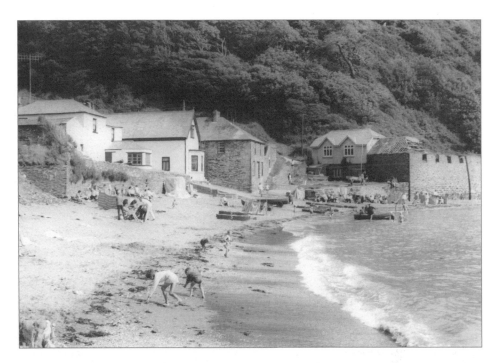

▲ **POLKERRIS,** *The Beach c1965* P65079

Children play on the beach and collect flotsam from the tide line while their parents sit beside windbreaks. The roof on the fish palace has now almost completely gone. In the centre is the old lifeboat house with its slipway, built in 1903. A lifeboat station was established at Polkerris in 1859, when the first boat was given by the Rashleighs of Menabilly. The station moved to Fowey in 1922, and the lifeboat house later became a café and shop.

◄ POLKERRIS
The Harbour c1960
P65053

We are looking at the village from the end of the pier. On the far right a narrow street separates the old lifeboat house from the white-painted Rashleigh Inn, also in a prime location on the shore.

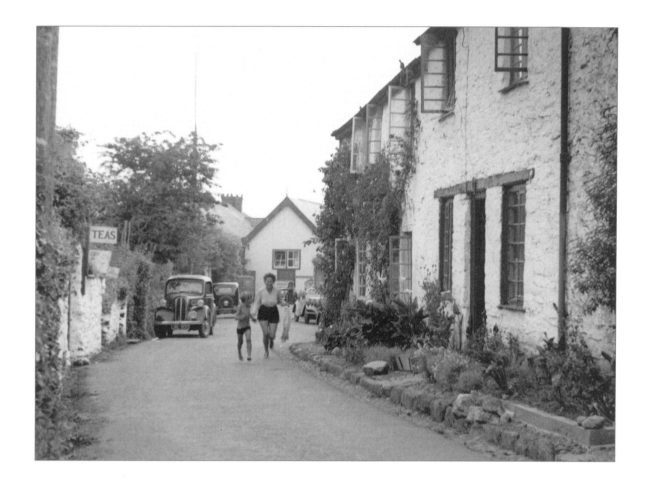

POLKERRIS, *The Village c1960* P65054

The gable end of the lifeboat house is seen in the background, almost at the end of the road through the village. Stone cottages, teas for sale and no unsightly road markings are the delights of this village.

PAR

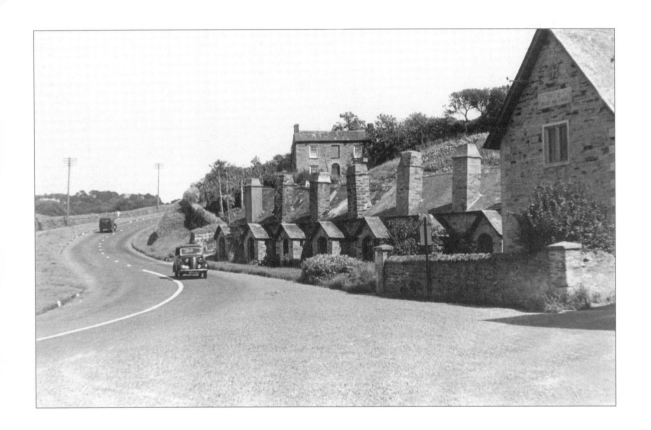

PAR, *Old Houses at Polmear c1955* P7005

The delightful row of almshouses stands unchanged at the bottom of Polmear Hill beside the road to Polkerris and Fowey. The simple road markings and telegraph poles are features of the 1950s period.

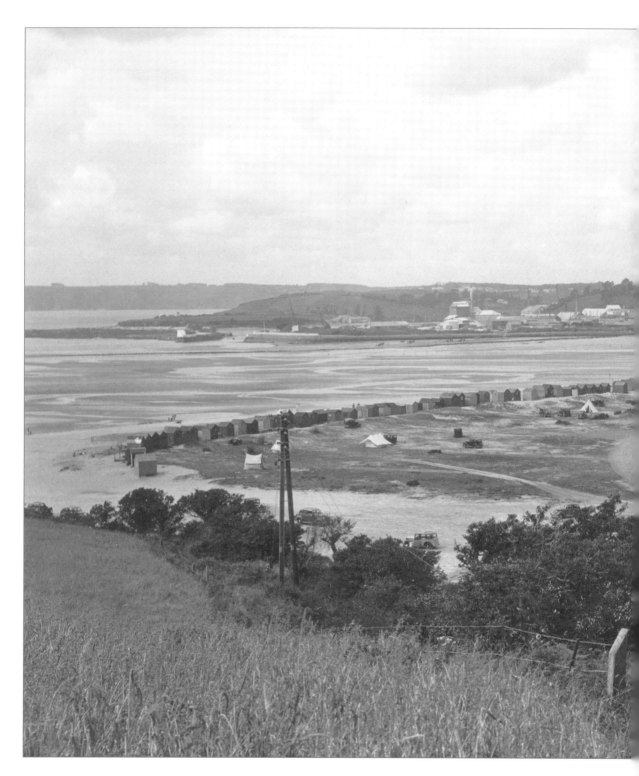

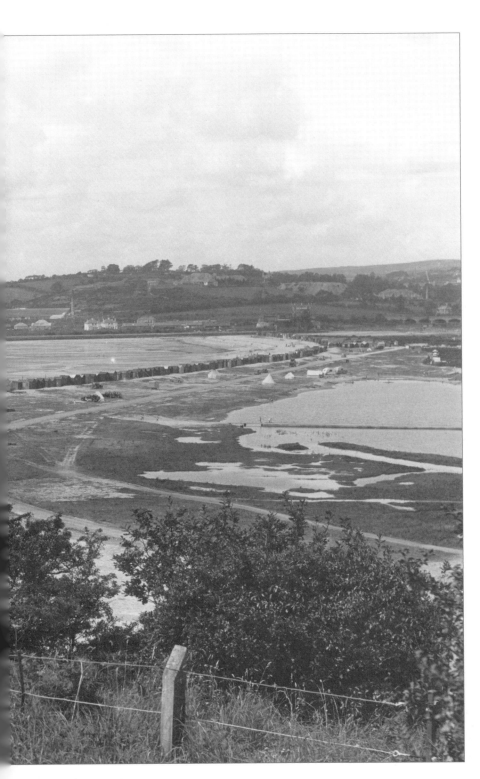

PAR
From Trill 1938 88574

Par Beach is seen at low tide with the china clay port of Par in the background. Bathing huts and tents line the shoreline of a sand spit which had been created over the previous 50 years, with a lagoon behind. This is now the Par Sands Holiday Park. The Ship Inn at Polmear is around to the right.

▼ **PAR,** *Polmear, The Ship Inn c1960* P7068

The 18th-century Ship Inn is appropriately named, for the sea once reached to this spot before the bay became silted up. Chapel Cottage on the left is also to be seen in the photograph of the almshouses (P7005, page 21).

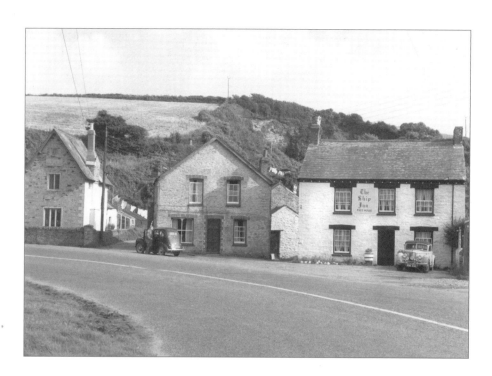

► **PAR**

The Beach Huts 1938
88578

The huts are arranged just above the high tide mark along the length of Par Beach. Much of the sand has been derived from waste entering the bay from mines and china clay works inland. The sea at this date had a milky colour, and one needed to go around to Polkerris to see clear water. Gasholders of the small Par gasworks are at the far end of the beach, below mine waste tips on the Mount.

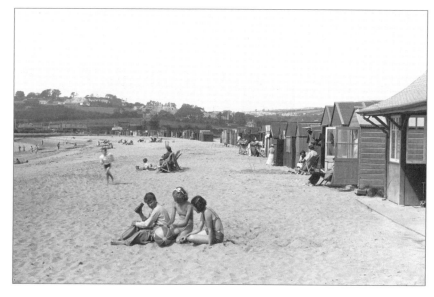

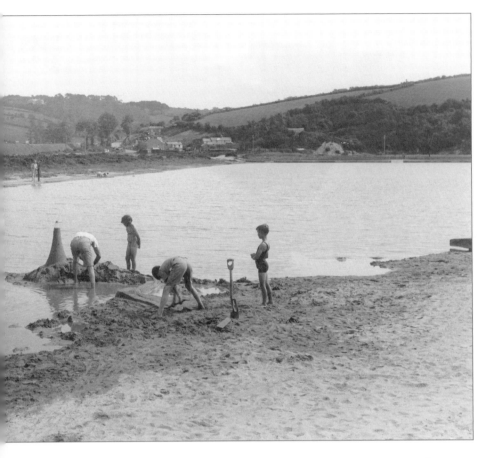

◀ **PAR**
*The Children's Pool
1938* 88577

The lagoon behind the
beach at Par makes a
good pool where the
children can play in
safety. The embankment
of the railway from Par
to the docks at Fowey
passes on the left.

▶ **PAR**
*Feeding the Swans
c1960* P7026

Birds to feed are a
universal attraction,
whether by the sea,
pond or river. A
regimented line of
beach huts gets a view
of the sea from the
bank behind, but the
inhabitants of the
solid-looking caravan
(right) must make do
with just a view of the
pool.

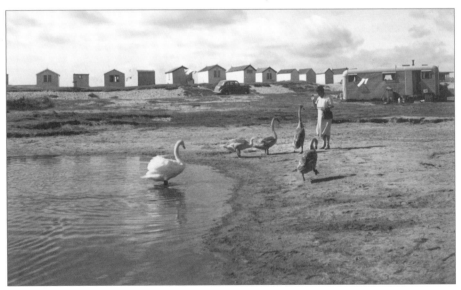

▶ **PAR**
The Beach 1927
79886

It can be appreciated from this photograph how the bleak area of beach and pools resulted from the infilling of the bay by silt and sand from the china clay industry; the old cliff line can be seen behind. There is industry in the foreground, with the smoking chimney of a china clay dry, railway trucks at a repair works and the gasworks on the left.

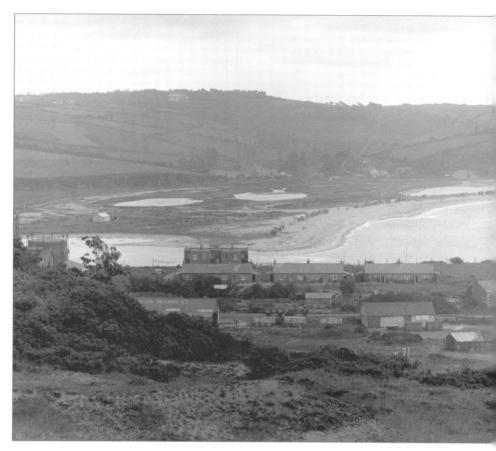

◀ **PAR**
The Harbour from the Mount 1927 79875

The busy port is seen from almost from the same viewpoint as No 79886, above, but looking to the right. Two steam coasters and a sailing ship lie alongside the main quay loading china clay from railway trucks, while at the near end is a tug. Timber has been imported at another quay (right), and the tall Snow King steam flour mill is a prominent feature. Polkerris is in the distance, above the harbour entrance.

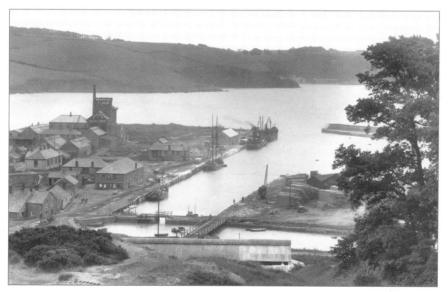

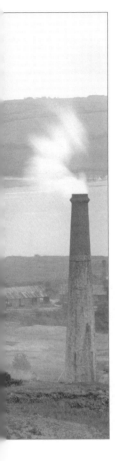

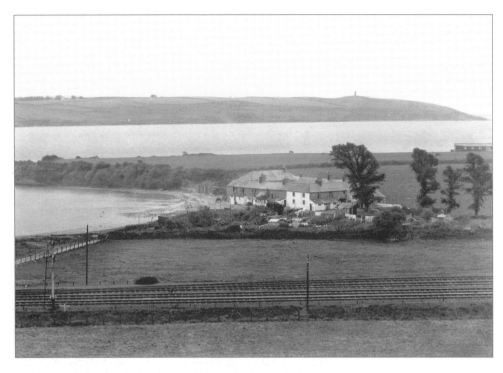

▲ **PAR,** *The Spit and the Bay 1927* 79879

We are looking further right again from the scene in No 79875 opposite. A candle manufactory stood on this side of the harbour at Par. Across the bay is the distinctive daymark on Gribbin Head. The tracks of the Great Western Railway cross the view in the foreground.

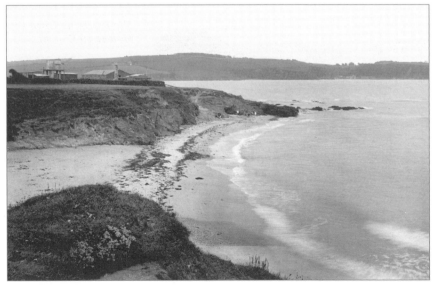

◄ **PAR**
The Spit Beach 1927
79881

This is the first beach around the corner from the main breakwater of Par Harbour. Steps cut into the rock lead down the cliff from Spit Point.

PAR
The Mount c1960
P7037

The Mount stands in a prominent position overlooking Par harbour and the bay. It was the former counting house or offices of Par Consols, a rich copper and tin mine in the mid-19th century. The Mount is now incorporated into a housing development, and it is surrounded by an estate of small dwellings.

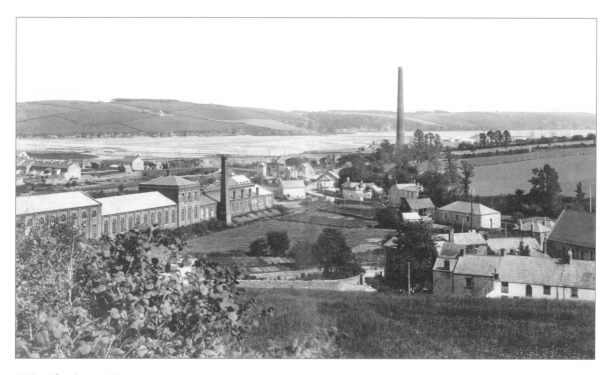

PAR, *The Bay 1898* 41635

This scene is full of industrial interest. The long range of buildings on the left is the Cornwall Minerals Railway locomotive works, built in 1872-74 by Sir Morton Peto. The Great Western Railway crosses in front of the tidal sands of the bay, and the very tall chimney belonged to the lead smelting works, which had already closed at this date. Trill Farm is seen among the fields across the bay (left), and Polkerris too (centre).

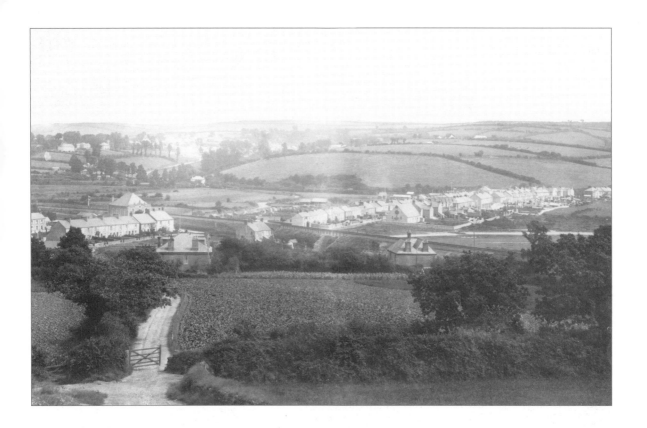

PAR
Par Green and Tywardreath 1904 52322

The Great Western Railway cuts across the scene, with the ribbon development of Par Green on the far side to the right. The roof of the Wesleyan chapel of 1864 is prominent on the left, and above it is the well-concealed village of Tywardreath. The smaller church of the Good Shepherd (1896) can be seen between the railway embankment and Par Green. The photograph was taken from the waste tips of Par Consols Mine on the Mount.

29

▶ **PAR**
Par Green 1904
52325

We are looking east along Par Green from the railway bridge. The Cornish Arms with its porch and a sign hanging from the roof is on the left. A group of pedestrians passes a wall and a shaded vacant plot between the railway and the church of the Good Shepherd.

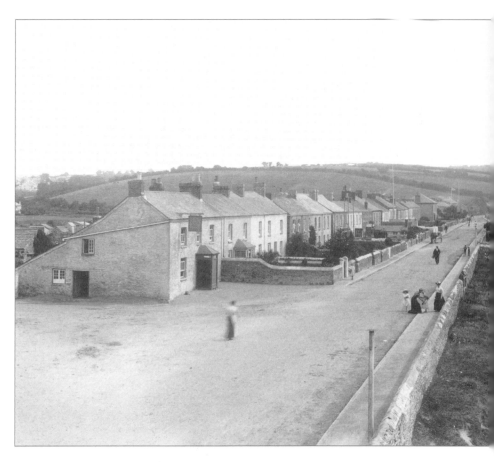

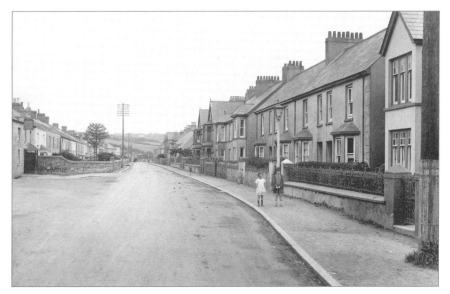

◀ **PAR**
Par Green 1927 79877

The photograph was taken from the road this time, and we get a closer view of The Cornish Arms (left). There is still no traffic, but telegraph poles have appeared, and a monkey puzzle tree has grown up in a garden (left). The clothes of the children by the gas lamp are noticeably different. They stand in front of a row of houses which were developed on the vacant plot seen in 1904 (52325 above).

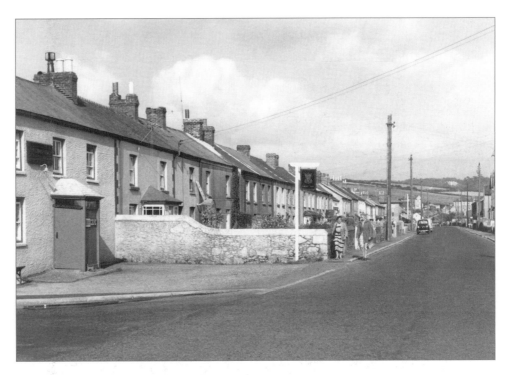

▲ **PAR,** *Par Green c1960* P7069

The Cornish Arms on the left has got a new sign on a post by the roadside, the monkey puzzle has been felled, and there is now a tangle of overhead electric wires spreading out from their poles. Par Green has since been made a one-way street, and the pub is a private house.

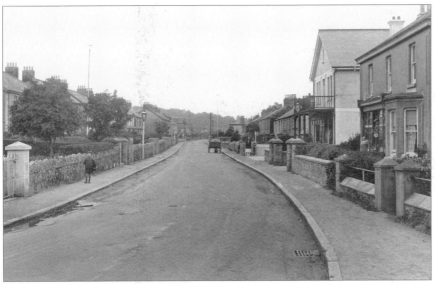

◄ **PAR**
Par Green, 1927 79878

This is the reverse view along Par Green, looking west. It is mostly a residential street, illuminated by gas lamps at this date; but there is a group of shops on the right. The tallest building is still a store (trading as Costcutter today), but the combined shop and house in the foreground has been demolished to make way for a car park.

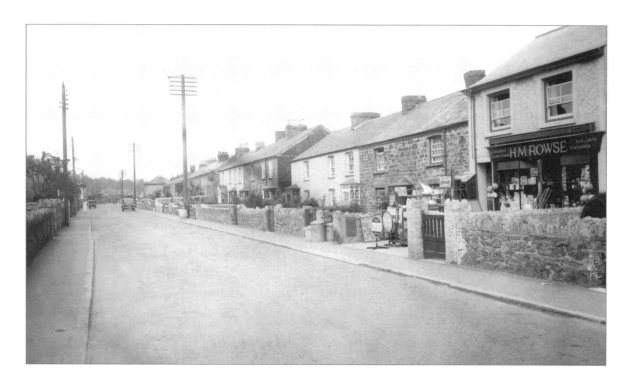

▲ **PAR,** *Par Green 1938* 88570

This photograph was taken a little further along the same street as No 79878 on page 31, showing the next shop, where H M Rowse is selling all sorts of stationery goods and newspapers. Gigantic telegraph and electricity poles tower over the terraces of humble cottages and the few small cars. The road surface has greatly improved since 1927.

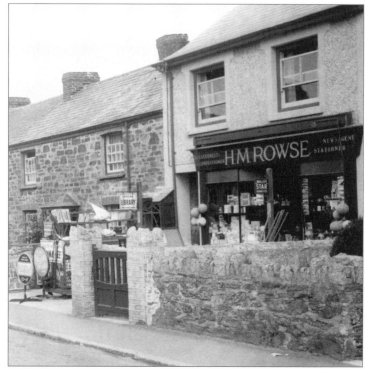

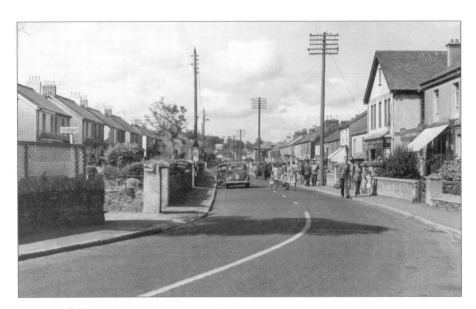

Par Green c1955
P7017

Par Green begins to look narrower and congested with the addition of more cars, wandering pedestrians and a white line in the road. A sign opposite the shops warns motorists of the low railway bridge at the far end of Par Green.

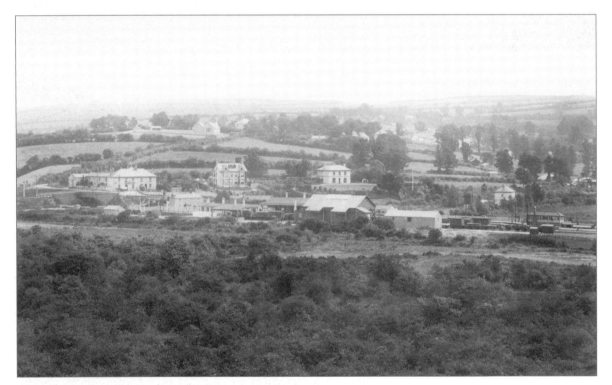

PAR, *The Station from Scobell 1904* 52326

The station buildings and goods sheds are at the junction between the main line and the Newquay branch. On the left a wide-arched bridge takes Eastcliffe Road over the main line railway and past The Royal Hotel (now The Royal Inn), the first of three large buildings along the road.

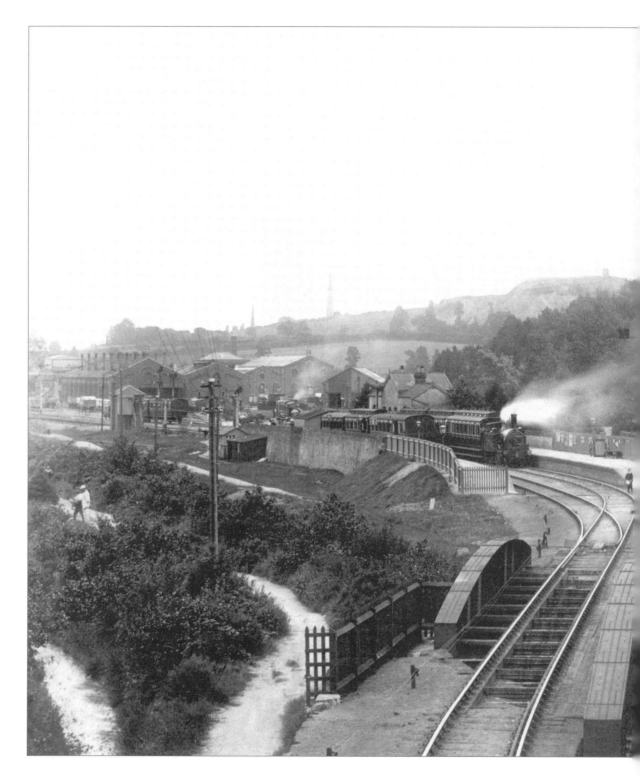

ST BLAZEY

ST BLAZEY
The Station 1904 52319

There are two trains in the station, one barely visible in the background (centre left). The one facing the camera is about to depart for Newquay, crossing the bridge onto the single track to climb up through the Luxulyan valley. Beyond the station can be seen the large Cornwall Minerals Railway locomotive works, with the abandoned Par Consols copper mine on the skyline.

35

► **ST BLAZEY**
The Fountain 1904
52323

A pony and trap (just visible, centre) pass behind a shady haven at the crossroads junction of St Blazey Road, St Andrews Road and Middleway. Rough granite stones provide the enclosure to contain a fountain and the Queen Victorian Jubilee Lamp of 1897. A period signpost indicates the directions on the left.

◄ **ST BLAZEY**
The Church and Cottages 1893 32578

This is a delightful view of the 15th-century church, which has a plain tower without pinnacles. The cottages have small gardens, walled enclosures, sheds and washing lines. The line of the Par to Newquay railway can be seen across the valley. It is interesting to note that the tide came up to this point when the church was built.

▲ **ST BLAZEY,** *The Church c1965* S8057

The church was restored twice during the Victorian period. The granite tower has a small niche below the window on the second stage. This is how the church is seen by motorists coming from St Austell, before the road passes below the solid churchyard wall on the right. Other travellers might be tempted to call at The Cornish Arms outside the churchyard gate.

◄ **ST BLAZEY**
Fore Street c1956 S8024

The Palace Cinema is showing three films: Charlton Heston stars in *The Private War of Major Benson,* Jane Wyman in *Lucy Gallant* and Tony Curtis in *Rawhide Years,* which date this photograph to 1956 at the earliest. This is the busy A390, but a lull in the traffic has allowed the photographer to stand in the middle of the road.

ST BLAZEY
Bridge Street and the Luxulyan Valley c1955
S8012

Fore Street leads into Bridge Street as the A390 heads east to cross the valley on its way towards Lostwithiel. There is a classic Guinness advertisement (right) on the wall of the tobacconist's shop, which has since closed. Amazingly, the plot next door is still derelict after half a century. The shop corner on the extreme left is Kittow Brothers', which appears in the centre of photograph S8024 on page 37.

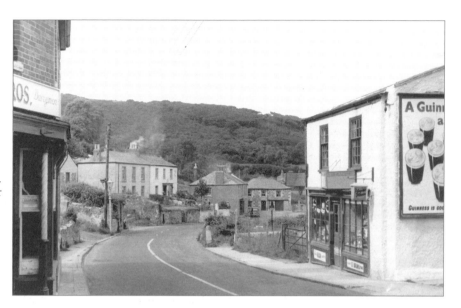

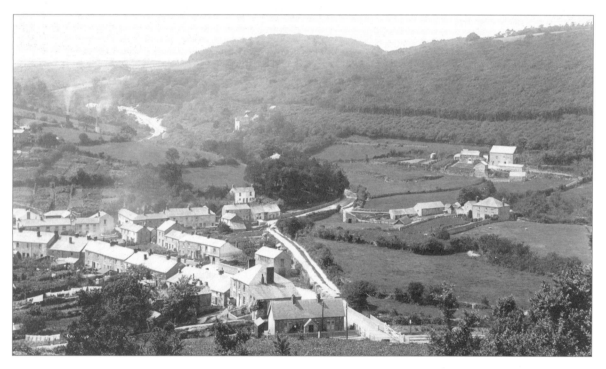

ST BLAZEY, *The Luxulyan Valley 1893* 32575

The main road has a level crossing over the Newquay railway in the foreground. The camera looks towards a side valley, with Prideaux Wood and Wood Mill on the right, and two smoking chimneys of the Wheal Rashleigh clay dries on the left. There is a real community here of cottages, gardens and allotments, but most have since been demolished, and the road has been realigned.

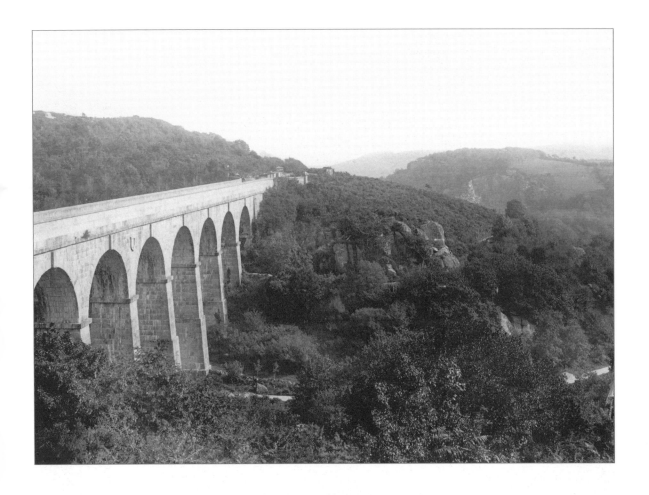

ST BLAZEY, *The Luxulyan Valley 1895* 37072

We are looking south across the Luxulyan valley. The magnificent Treffry Viaduct was built in 1842 to carry a tramway and an aqueduct. The woodland in the rocky valley has matured, and the view today is nowhere near as open. This was the first viaduct to be built in Cornwall, but it was bypassed in 1874 by the Newquay railway, which runs along the valley floor beneath. Both railways served quarries, mines and the china clay industry.

ST AUSTELL

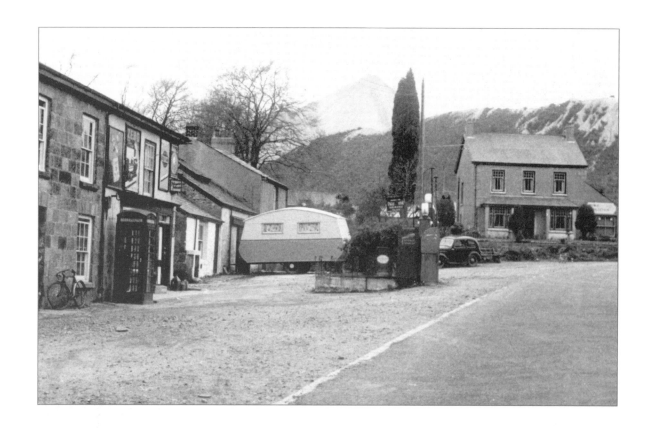

CARTHEW, *The Village c1955* C39005

This photograph gives a bleak impression of the china clay district near St Austell, with a partly overgrown waste tip a higher conical white tip looming behind the houses. Petrol pumps (centre) stand outside a small shop, which displays a number of advertisements on the wall above the telephone kiosk. A caravan of the period is parked beyond.

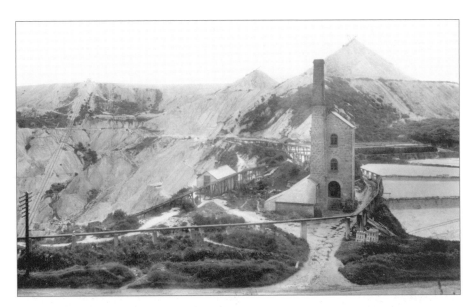

CARTHEW
The Clay Workings
1927 79867

The china clay industry dominates the landscape around St Austell. This is the Lower Ninestones china clay pit, with waste being hauled up inclines to older flat-topped tips on the left and newer 'sky tips' on the right. The tall engine house with a square stack contained a beam engine for pumping clay from the pit to the thickening pools on the right.

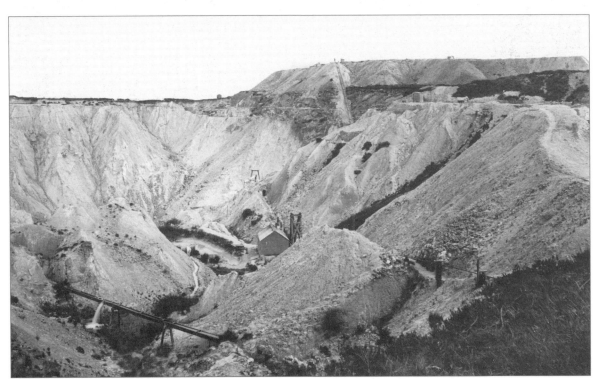

ST AUSTELL, *Carclaze Clay Works 1912* 64764

Carclaze started as an open excavation for tin, and it was often visited by tourists in the early 19th century. Only later did it become a china clay working. This view shows a confusion of waste tips and water courses, with work taking place at the very bottom of the pit. Clay slurry was piped to the dry at Charlestown harbour.

ST AUSTELL
1890 27620

This photograph looks from the west towards St Austell in its rural setting. Housing has not yet developed out into the fields where tall elm trees break up the line of the hedgerow on the right. The tower of Holy Trinity church is just visible above two fields in the centre of town, and terraced houses along Bodmin Road and the Workhouse can be seen towards the left of the picture.

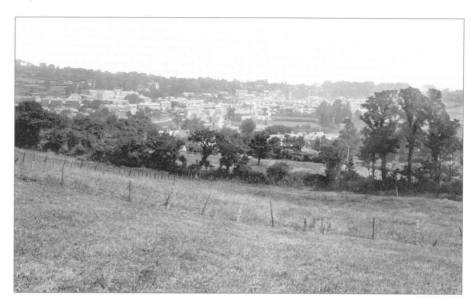

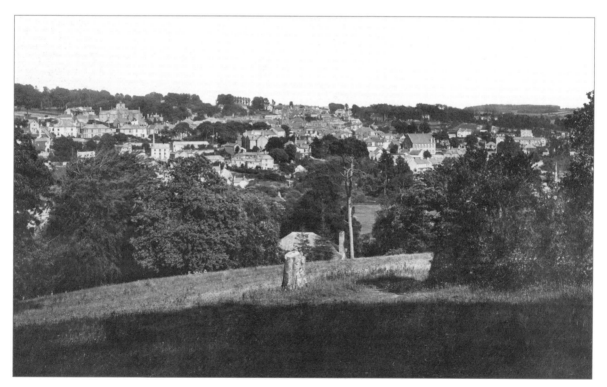

ST AUSTELL *1920* 69780

This is a closer view of the town. At this date it is still surrounded by the countryside, and woodland dominates the skyline. Up the hill to the left is the Workhouse, with the Trenance flour mill and its chimney below. The prominent building towards the right is the Baptist chapel.

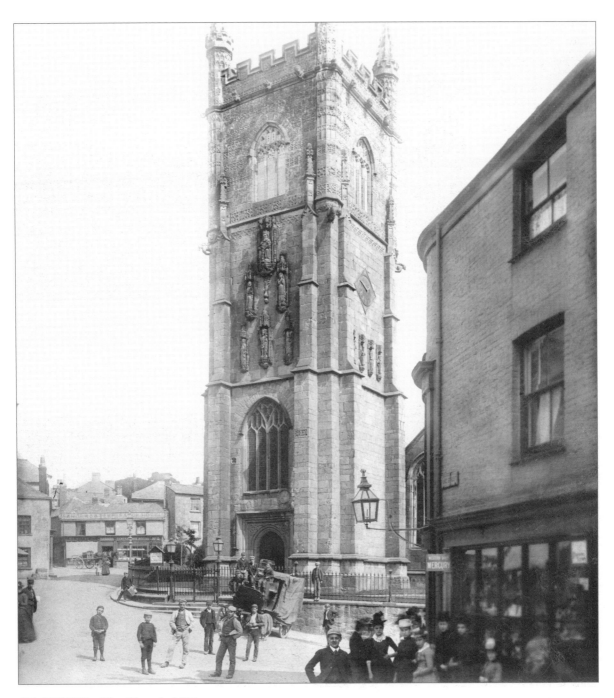

ST AUSTELL, *The Church 1890* 27626

The late-15th century tower of Holy Trinity church is one of the finest in Cornwall; its west side has carved figures depicting the Trinity, the Annunciation and the Resurrection. Quite a crowd has gathered for the photographer in front of the church and also outside W H Smith's premises on the corner, where the *Western Daily Mercury* is for sale.

43

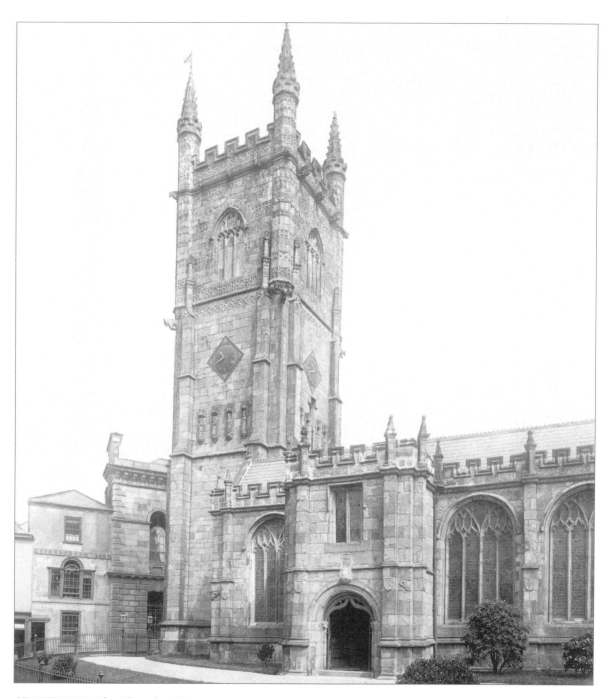

ST AUSTELL, *The Church 1890* 27625

A view from Church Street showing the ornate tower, the south porch with a priest's chamber above, and the crenellated south aisle. The clock faces on the tower date from 1885. The granite façade of the Town and Market Hall looms behind, with The Queen's Head hotel on the left.

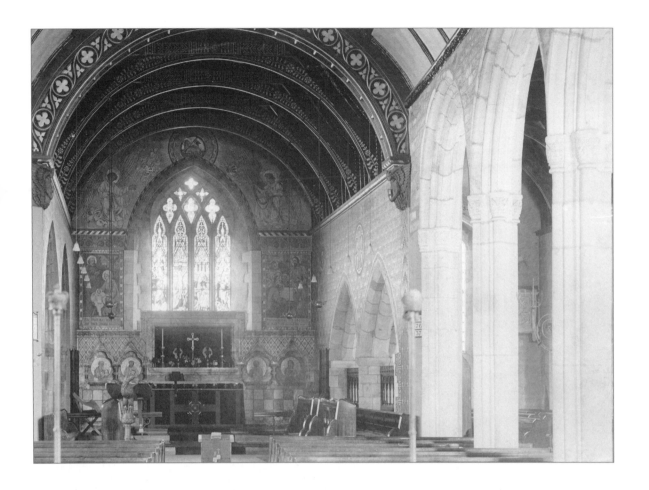

ST AUSTELL, *The Church, the Interior 1890* 27628

Arcades supported by tall granite piers with carved capitals separate the nave from the north and south aisles. The earlier chancel beyond has smaller arcades and is slightly out of alignment. The church was restored in the 1870s, when the chancel was re-roofed and new benches were installed.

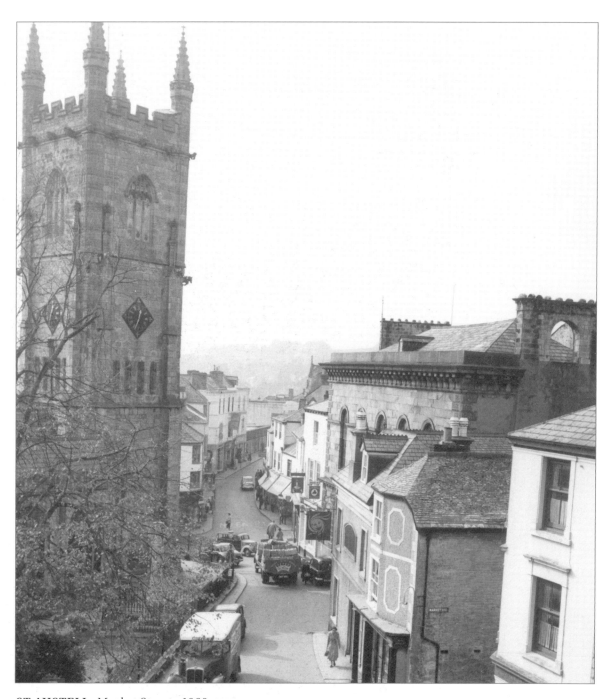

ST AUSTELL, *Market Street c1960* S6039

This photograph was taken around lunchtime, and parked cars are beginning to congest the scene. A lorry (centre) is delivering Corona soft drinks to The Queen's Head beyond the Market and Town Hall, while on this side of it is the hanging sign of The Sun Inn. The large Italianate-style Town Hall, with the Market Hall below, was built in 1844.

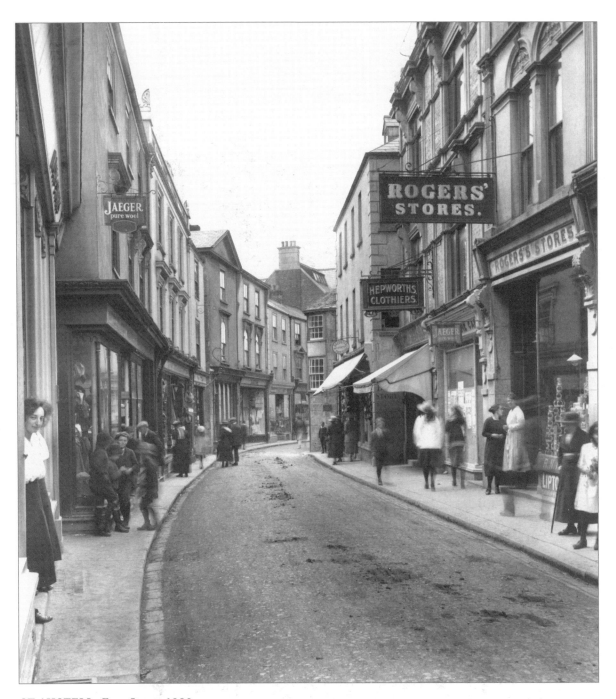

ST AUSTELL, *Fore Street 1920* 69787

Towards the west end of Fore Street, a gilded glass sign advertises Hepworths the tailors beyond Reuben Rogers' grocery stores (right). Evidence in the centre of the road suggests that horse traffic has recently passed this way. Much of this scene has been redeveloped, although the building with a carved date of 1893 above Hepworths survives.

47

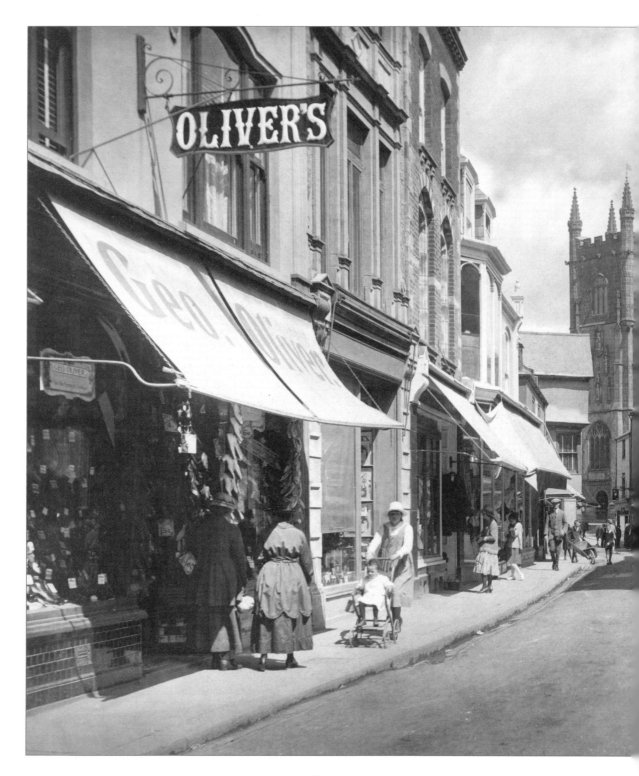

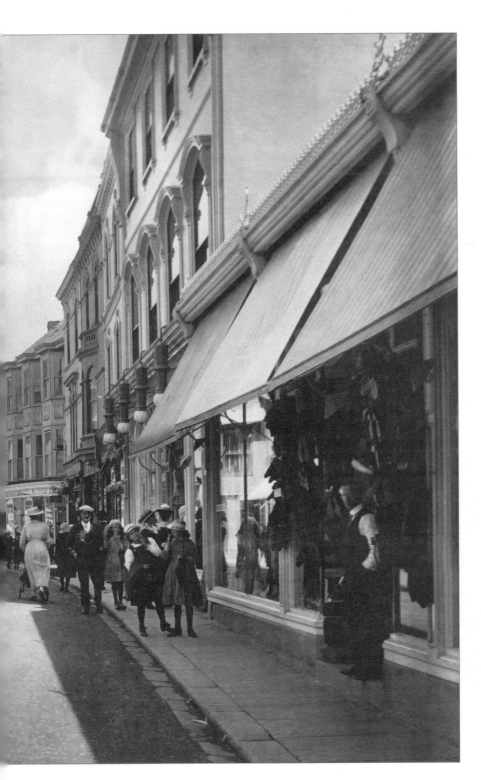

ST AUSTELL
Fore Street 1920 69784

The church tower presides over the east end of Fore Street, where two prams and a barrow are the only wheeled traffic on a sunny day. George Oliver's shoe shop (left) was one of several Cornish branches in the early 20th century; it still exists in a modernised form as Messrs Timpson. The projecting storeys of Tremayne House partly obscure the church tower on the left.

49

▶ **ST AUSTELL**
Fore Street c1950
S6010

The Midland Bank occupies a small but distinctive stone building next door to Mill Bay laundry, and Myners the butcher's uses the ground floor of Tremayne House (left). The old-style frontage of Boots the chemists can be seen across the road. The shoppers' summer dresses suggest the time of year.

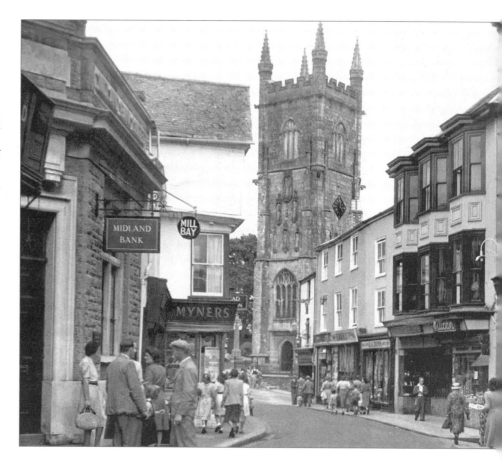

◀ **ST AUSTELL**
Fore Street c1960
S6043

Timothy Whites & Taylors was once a familiar shop selling medicines and household goods on many high streets. It was taken over by Boots, whose shop on the right displays a flag advertising the Booklovers' Library. Beyond the Midland Bank, the old Tremayne House has lost its upper floor, although Myners the butchers still occupy the shop below.

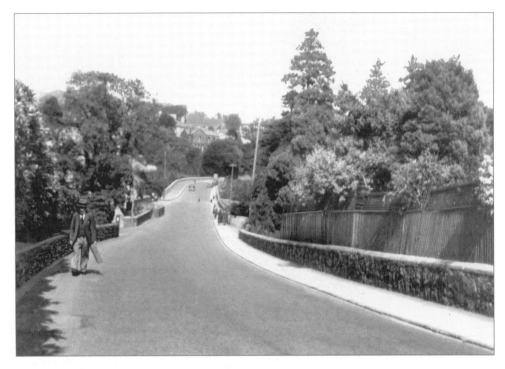

▲ **ST AUSTELL,** *Truro Road c1955* S6007

This was the main road into St Austell from Truro and the west before the building of the ring road. The view looks towards the town from the causeway across the valley, with New Bridge at the bottom of the hill.

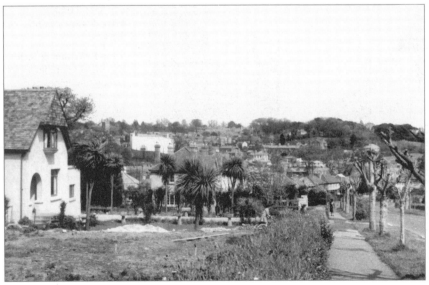

◀ **ST AUSTELL**
The View from the Ring Road c1955 S6021

The bypass on the south side of town was opened in 1926; it was much needed to relieve the narrow streets of both local china clay and through traffic. It still carries a large volume of traffic, although all is quiet here – we are looking down Penwinnick Road. The white block of the 1930s Odeon cinema dominates the town centre in the background (centre left).

ST AUSTELL
Pondhu Road 1912
64761

This thatched cottage with its little garden stood in Pondhu Road, in the valley bottom to the south west of the town centre. There are cart tracks in the mud of the lane, but a single telegraph pole brings some modernity to the scene. The site of the cottage is now an open space for parking, and houses have been built on the left side of the lane.

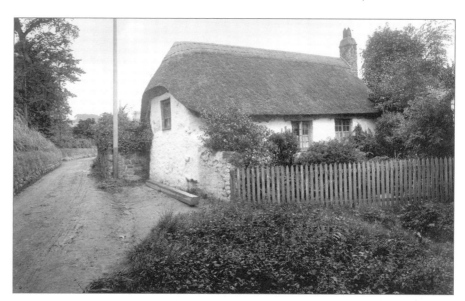

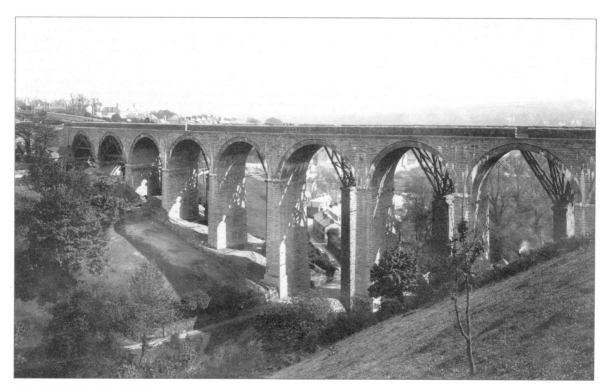

ST AUSTELL, *The Viaduct 1898* 41391

The granite and brick arched St Austell or Trenance Viaduct was completed by the Great Western Railway in the year of this photograph to replace I K Brunel's timber fan viaduct of 1858. The latter can be seen behind the new double-track structure, and its old stone piers remain to this day.

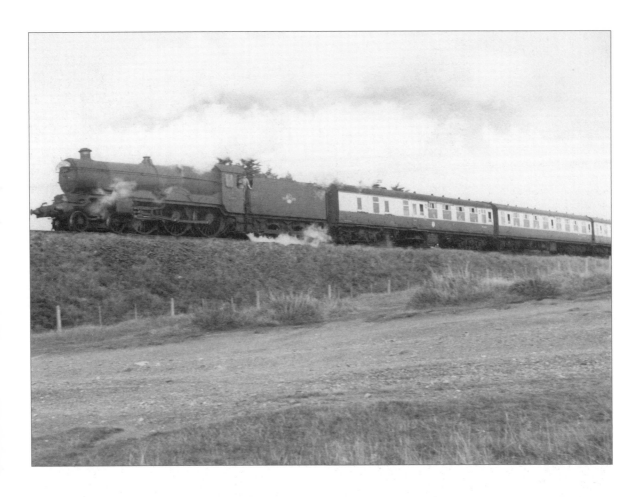

ST AUSTELL, *The Cornish Riviera Express c1955* S6066

A Great Western steam locomotive hauls the Cornish Riviera Express towards St Austell from Par. The train is seen from the Carlyon Bay golf course near the Crinnis arch. Diesel locomotives made their first appearance in the late 1950s, and the last steam train ran in 1964.

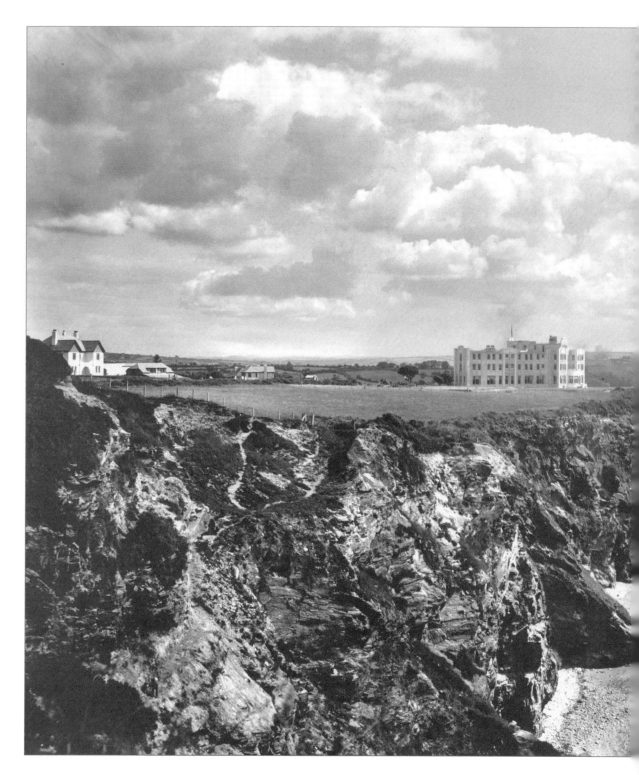

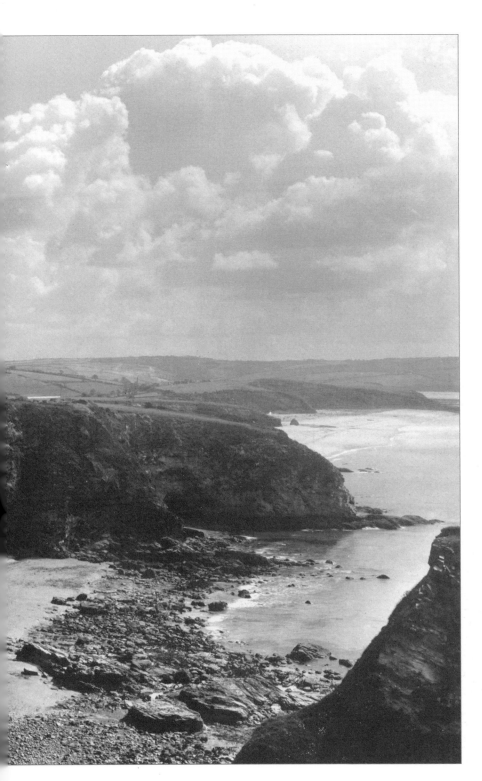

ST AUSTELL
The Carlyon Bay Hotel
1930 83237

Tourism was boosted in
1930 by the opening of the
high-class Carlyon Bay
Hotel on a headland
overlooking St Austell Bay. It
was designed in the very
latest architectural style,
and there was a golf course
adjacent to the site, which
was described at the time as
an 'embryo resort'.

ST AUSTELL
The Cornish Riviera Club c1955 S6334

This complex was built in the 1930s, and became a popular venue for concerts and dancing; there were facilities for sports, such as the tennis court on the right. It later became known as the Cornwall Coliseum.

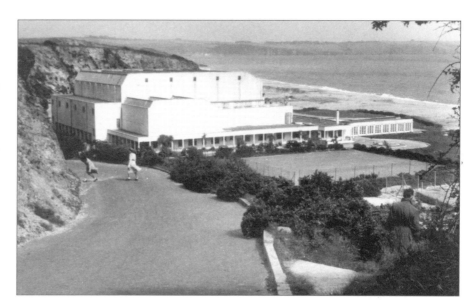

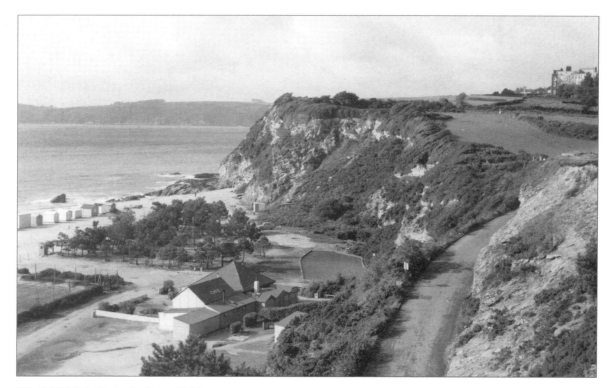

ST AUSTELL, *Crinnis Bay c1955* S6055

Tennis courts, a café and beach huts are situated on the sands reclaimed from the sea beneath the cliffs; down them the steep access lane descends to the Riviera Club. The Carlyon Bay Hotel is visible on top of the cliffs (right).

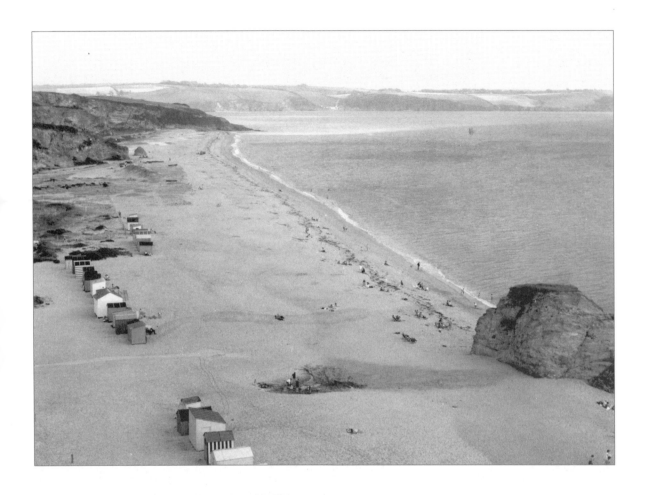

ST AUSTELL, *Crinnis Beach c1955* S6067

As at Par, the Crinnis Beach is also largely a result of the deposition of waste from the mining and china clay industries. The old cliff line is protected by a wide expanse of sand, and the highest tides barely surround Crinnis Island. The paler seawater beyond the point is polluted with clay brought into the bay by the Par stream.

CHARLESTOWN

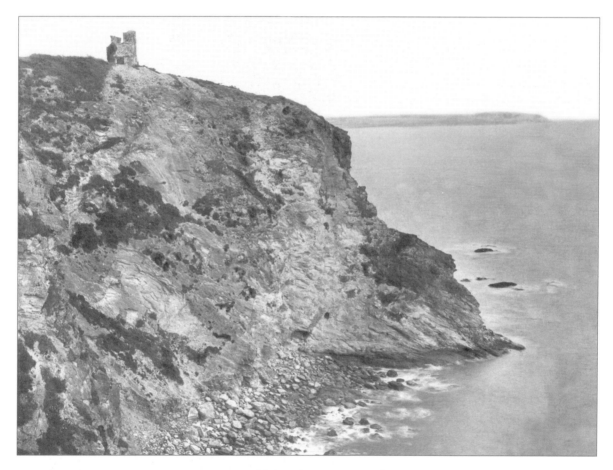

CHARLESTOWN, *Apple Tree Mine Beach 1912* 64786

This photograph is a good illustration of the crumbling nature of the shale cliffs in this part of the coast – note the pile of boulders on the beach below (centre). The ruined engine house on top of the cliffs belonged to the Apple Tree or South Crinnis Mine, last worked for copper ore in 1840-66. Gribbin Head is in the distance.

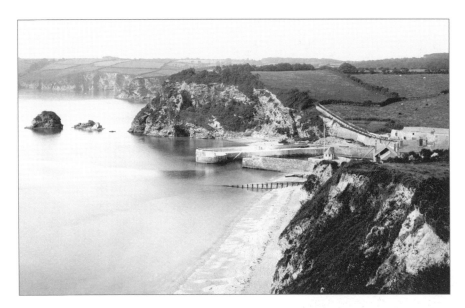

CHARLESTOWN
From the East 1890
27632

Tranquil waters lap around the two outer piers and the narrow entrance to the dock, which was cut back into West Polmear Cove around a century before this photograph was taken. This view indicates what an unlikely site Charlestown is for a harbour; yet the little dock was completed in 1801 by Charles Rashleigh, after whom it was named, for exporting china clay and mineral ores and importing coal.

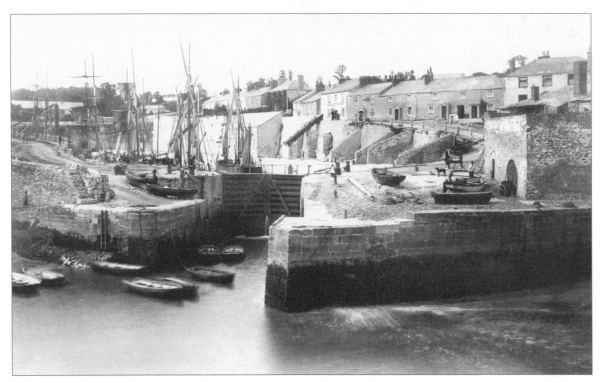

CHARLESTOWN, *The Harbour c1885* 16771

The dock is seen from the outer breakwater. At least seven sailing vessels are floating in the harbour, thanks to the lock gates which hold in the water. Chutes descend from Quay Road in front of the terraced houses for loading china clay. On the extreme right is a disused limekiln with two arches.

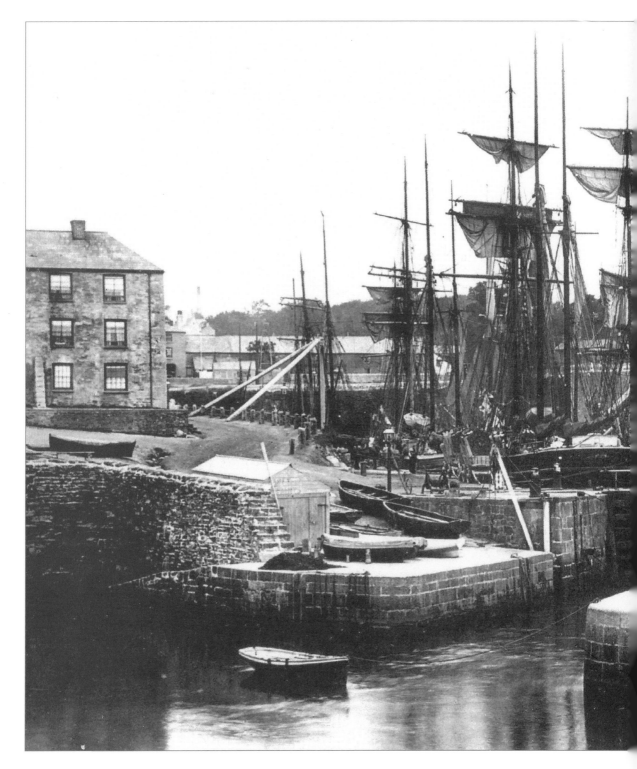

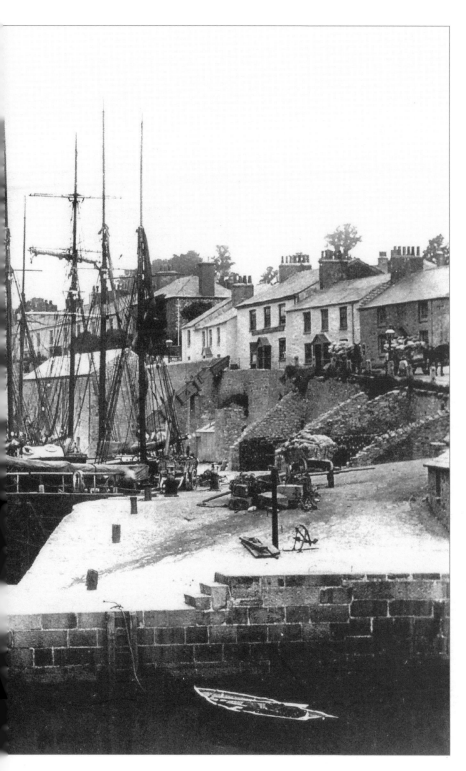

CHARLESTOWN
The Harbour 1904 53050

The floating dock is filled with sailing vessels, and two horse-drawn clay wagons wait in front of the houses on the right. A derrick crane on the left is for unloading coal, while a small crane near the lock gates is for lifting rowing boats in and out of the water in the outer harbour.

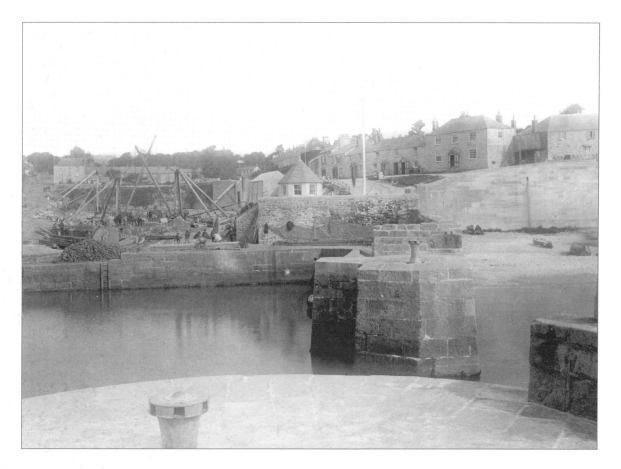

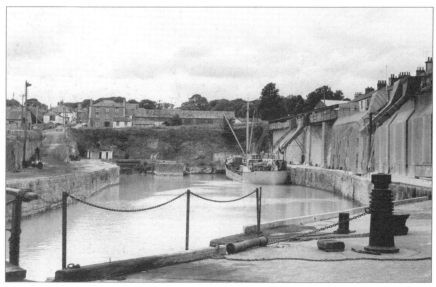

◄CHARLESTOWN
The Harbour c1955
C62073

Looking up the harbour, we can see a small Dutch coaster loading china clay at two chutes. Such motor ships were common around the Cornish coast from between the wars until the 1970s. The Rashleigh Arms stands above the rock-cut cliff at the back of the dock.

◄ **CHARLESTOWN**
The Harbour
1890 27634A

Capstans (foreground and opposite it) on the outer piers were used for helping ships in and out of the difficult harbour entrance. A small octagonal harbour office has been built atop the limekiln (centre). The many derrick cranes and signs of activity would appear to indicate that work is being done to repair the lock gates and the inner dock entrance.

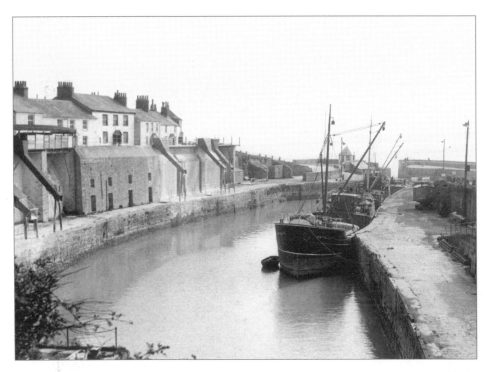

▲ **CHARLESTOWN,** *The Harbour c1955* C62086

Two motor coasters lie in the harbour, including the 311-ton *Antiquity* in the foreground, one of a familiar fleet of vessels owned by F T Everard & Sons. They have been discharging coal or are loading bagged clay, whereas the berths across the dock are for loading bulk clay, which was tipped into the chutes from lorries.

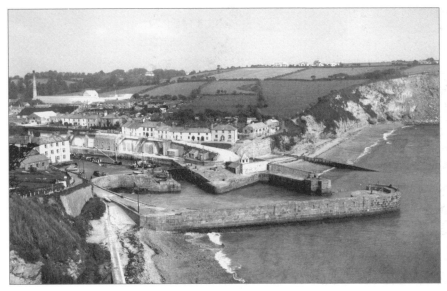

◄ **CHARLESTOWN**
The Harbour c1955
C62078

The perfect little port with its floating dock is surrounded by cottages, and the outer harbour is enclosed by breakwater piers. We can see how the coasters in the dock will have to reverse out and turn sharply to clear the outer harbour. The long building with a tall chimney (left) is the clay dry built in 1908 for processing clay from Carclaze Pit. From here the clay was trammed through a tunnel direct to the harbour.

CHARLESTOWN
The Beach 1890
27633

Rowing boats are drawn
up on the small shingle
beach on the west side of
Charlestown harbour,
with the Polmear Island
rock behind.

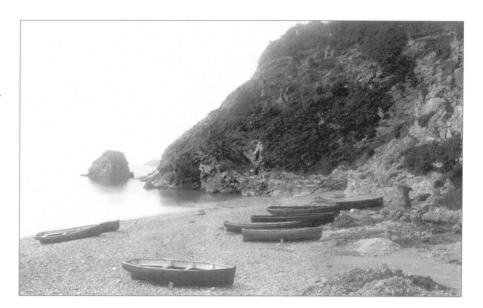

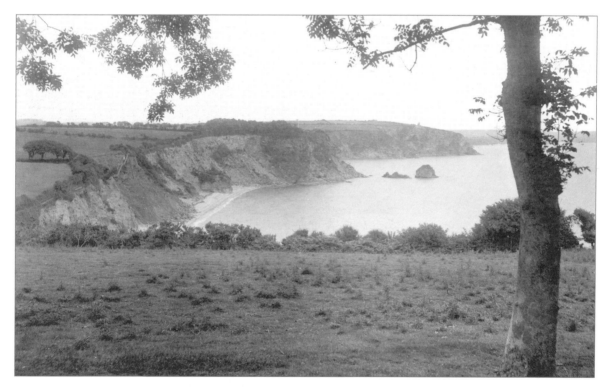

ST AUSTELL, *Duporth Beach 1912* 64775
Duporth Beach is just around the corner from Charlestown, and is separated from it by the headland and Polmear Island
offshore. We see it here from above Carrickowel Point; the photograph shows that there has been a recent cliff fall onto the
lonely beach. There are now houses and the Duporth Holiday Village along the slopes behind.

PORTHPEAN AND BLACK HEAD

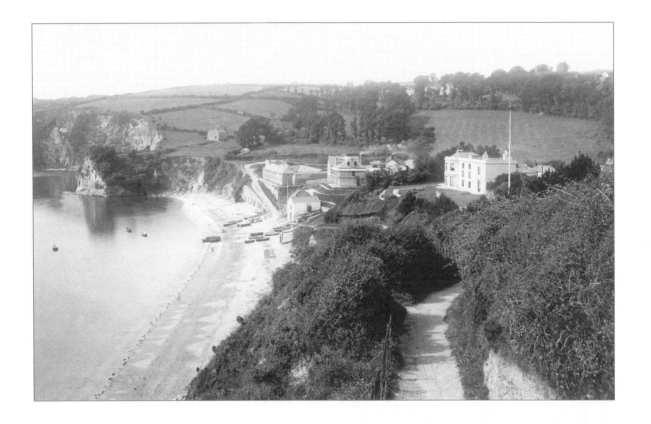

PORTHPEAN, *The Village 1890* 27636

By the time of this photograph, Lower Porthpean was becoming a small resort: the Glen Private Boarding and Lodging House was built here near the fish cellar in 1889. Porthpean House is the large white house on the right with a flagpole. The hamlet of Higher Porthpean is glimpsed behind the trees across the fields in the background.

PORTHPEAN
The Beach c1884
16778

Small fishing boats are drawn up on the beach, a ramp climbs past the fish cellar, and on the extreme left we can just see an arched incline to a limekiln which was in use from at least 1835. These are all reminders that the cove served an industrial function before the days of recreation. There are open fields behind Porthpean House with its well manicured lawns.

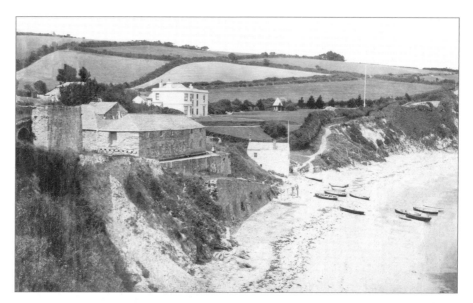

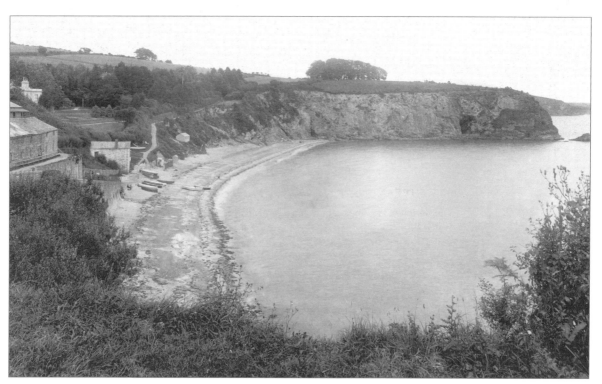

PORTHPEAN, *The Bay 1912* 64773A

Trees have begun to grow up on the slope beyond Porthpean House since 1884 (see No 16778, above), although the coast path is still prominent. The roof of the Glen House rises behind the fish cellar, and Carrickowel Point is on the right.

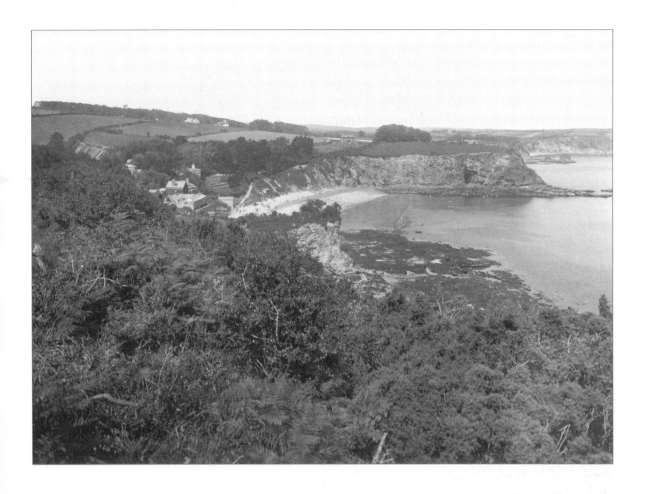

PORTHPEAN, *The Bay 1928* 81343

The setting of Porthpean, between two headlands, is quite
delightful. New houses have appeared along the hill above the
end of the beach.

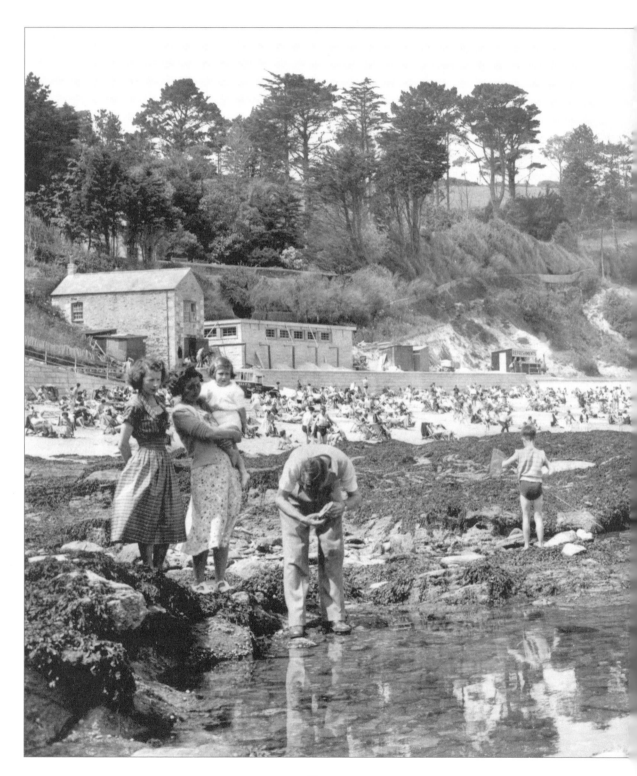

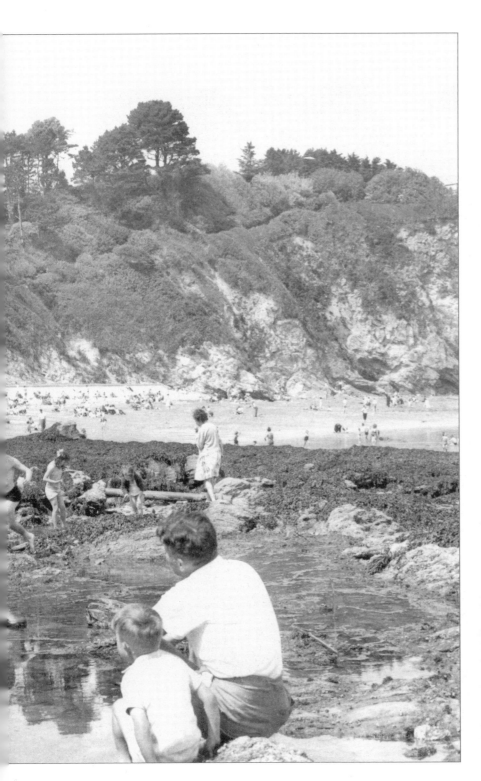

PORTHPEAN
The Beach c1955 P87005

This could be a bank holiday. The beach is packed with visitors and day-trippers from St Austell, while in the foreground children and their parents are model boating and fishing around the rock pools. A wall now protects the cliff behind the beach.

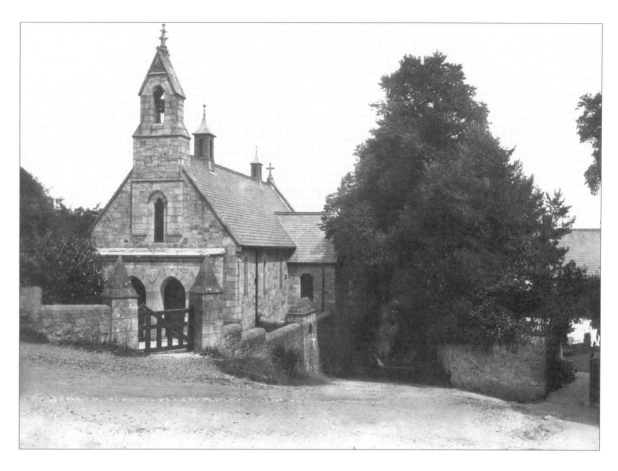

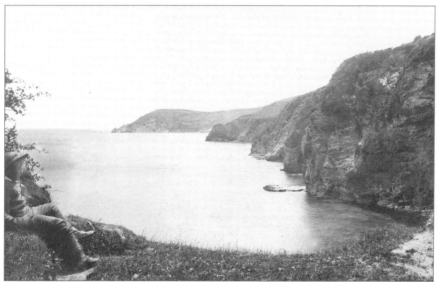

◄PORTHPEAN
The Cliffs c1884 16782

Here we see the coastline between Porthpean and Gerrans Point. Phoebe's Point is midway. A local boy provides interest on the left, but would he have appreciated this unspoilt view? Although the photograph was originally captioned 'Porthpean Cliffs & Blackhead', the distant headland is in fact Gerrans Point, which obscures Black Head from this viewpoint.

◄ **PORTHPEAN**
The Church
1912 64772

At Higher Porthpean, the robust chapel of ease, dedicated to St Levan, was built in 1885 and financed by Lady Graves-Sawle of Penrice at a cost of £1,000. 'Jesus came to them walking on the sea' is carved over the twin doorways below the bell cote.

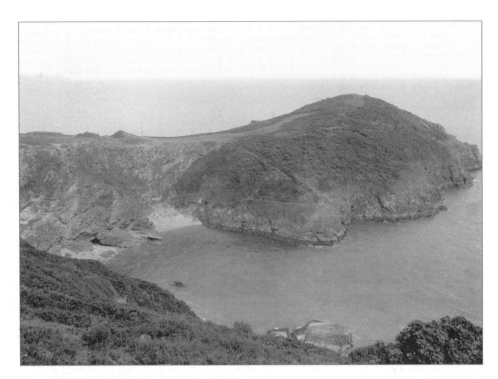

▲ **TRENARREN,** *Black Head 1912* 64769

Black Head is at the west end of the true St Austell Bay. This rocky promontory was defended in the Iron Age by an earthwork consisting of a rampart and ditch, which are visible across the top of the narrow neck. The headland itself is now owned by the National Trust.

◄ **TRENARREN**
Hallane Beach 1912
64768

The little valley of Trenarren reaches the coast just to the west of Black Head, and the stream cascades over the cliff onto the beach. The high rugged cliff gives way to the little Polgwyn Beach in the far distance.

TRENARREN
The Village 1912
64766

The small hamlet of slate-roofed farm houses and cottages lies at the end of a lane near Black Head, sheltered in the valley which climbs up from Hallane Beach. A local looks over the cottages, where it is washing day for at least one family (centre).

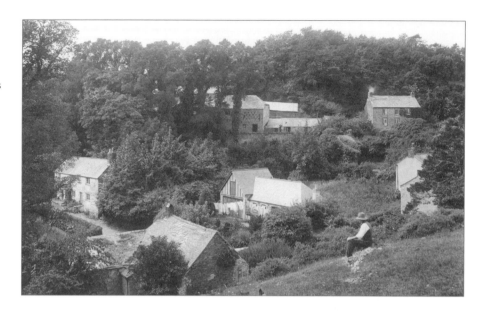

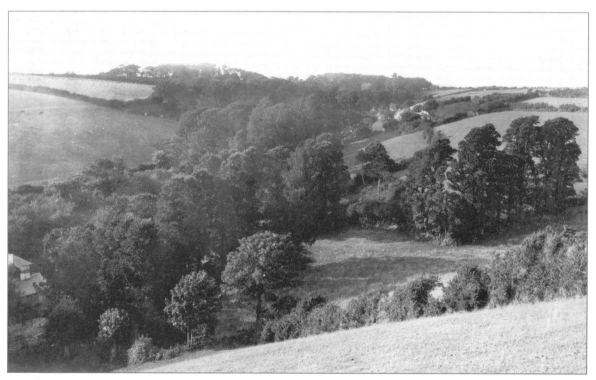

TRENARREN, *The Vale c1884* 16766

Looking inland from the high ground above Black Head, this view captures almost the whole of the little valley where trees thrive in the shelter. Trenarren hamlet is in the far distance, and the mill house at Hallane is on the extreme left.

PENTEWAN AND POLGOOTH

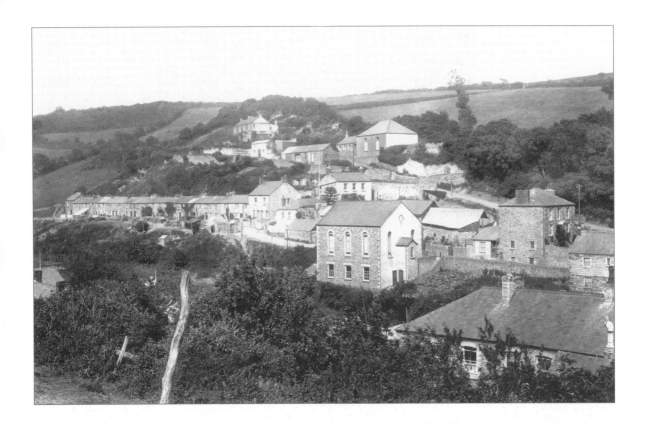

PENTEWAN *1904* 52244

The village expanded on a restricted site in the 19th century to house workers employed at the port and in local industries. The delightful terrace of low cottages follows North Street on the far side of the valley. Other houses climb Pentewan Hill (centre); here stands the Wesleyan chapel of 1880, now converted to a house. The more prominent Bible Christian chapel in the foreground was built in 1889 with a capacity of 250 seats, but it has since completely disappeared.

73

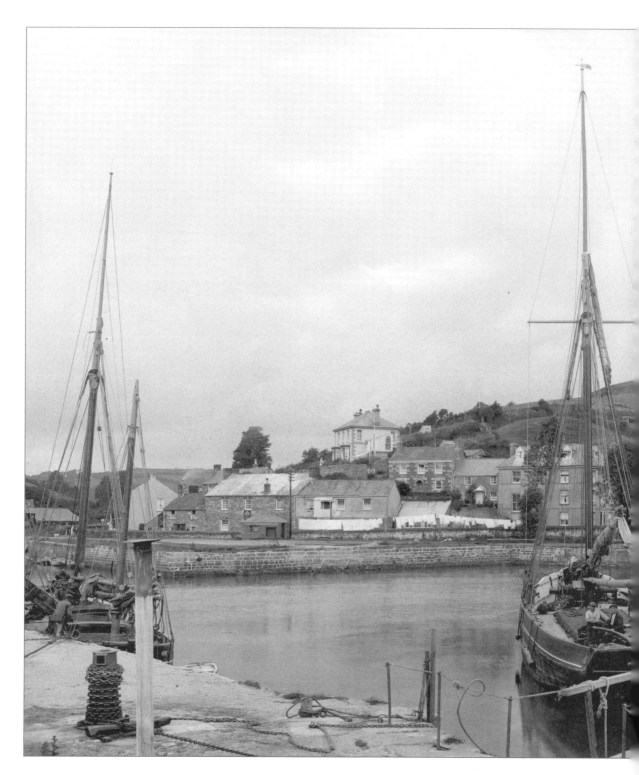

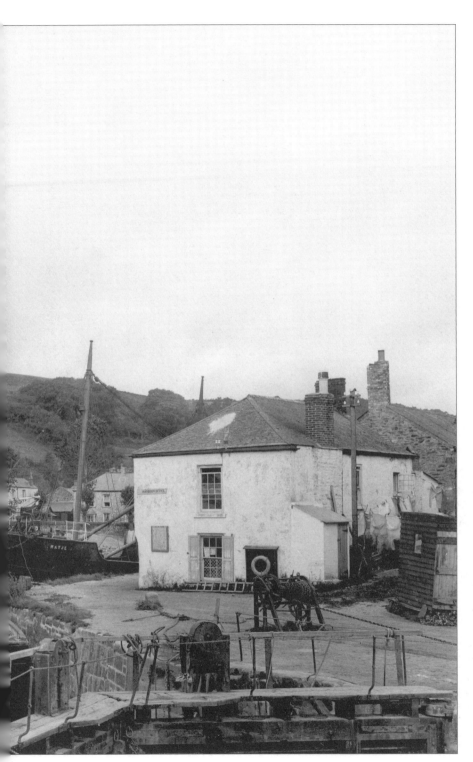

PENTEWAN
The Harbour 1927 79874

Pentewan was developed as a port in the 1820s for shipping ores and china clay, which were brought down from St Austell on a railway built in 1829. The sailing smack *JNR* of Plymouth is moored behind the sea lock gates, while the bow of a coaster emerges from behind the harbour office. The Ship Inn is on the far side of the basin (left). However, this picture shows the last days of Pentewan as a port: soon after, the harbour entrance became blocked with sand and silt.

PENTEWAN
The Square from the East 1938 88585

The Square is the heart of the village, just behind the harbour basin. T T Prynn's grocery shop is on the far side (centre) and the Central Stores, with the large awning, is on the right. Only the former survives today as a shop, now selling gifts.

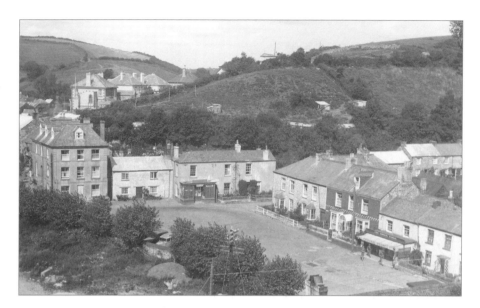

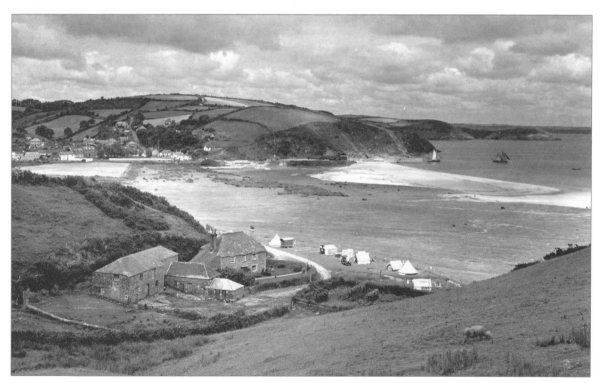

PENTEWAN, *Sconhoe Farm and the Beach 1931* 84126

Outdoor holidays are being pioneered here, with just a few tents and caravans on the edge of the beach at Sconhoe Farm. The deserted open ground has since been transformed into the Pentewan Sands Holiday Park. Pentewan village is on the far side of the beach, and two sailing boats set off from the harbour pier.

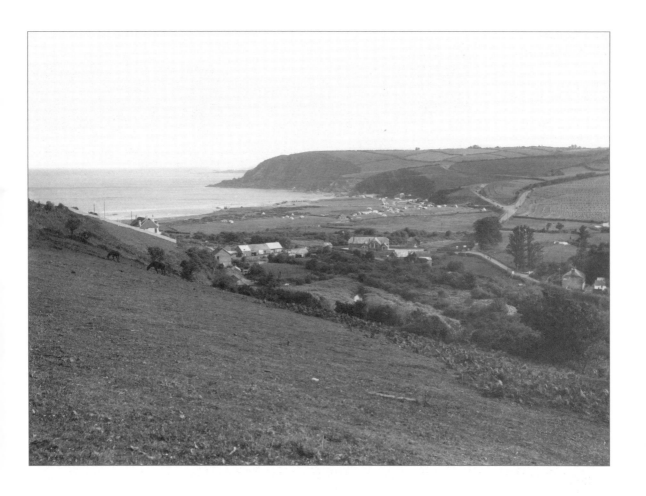

PENTEWAN, *From the West 1938* 88571

The village school is in the centre of the picture and the ground
behind the beach has now begun to be invaded by campers. The
road to Mevagissey climbs the hill to the right.

▶ **PENTEWAN**
The Valley 1912
64778

We are looking inland from near Pentewan, with the St Austell hills in the far distance. The road on the left curves past the houses of Nansladron, where the fields in the valley floor are now caravan and camping parks. The line of the Pentewan Railway is among the trees on the right-hand side of the valley.

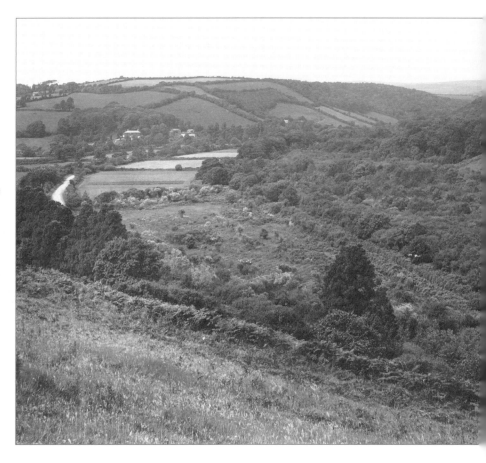

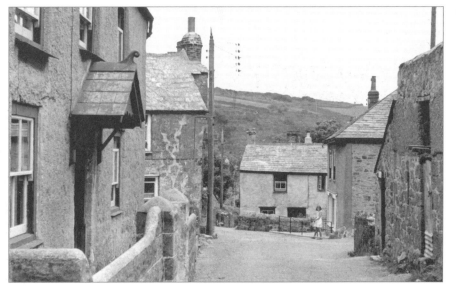

◀ **POLGOOTH**
The Village c1955
P242001

Polgooth grew up in the 19th century as a mining village to the south west of St Austell. The girl (centre) stands outside the post office stores, which is still a lifeline in the village. There is an air of dereliction in this picture; the site of the old barn on the right has been redeveloped as the Polmewan Flats.

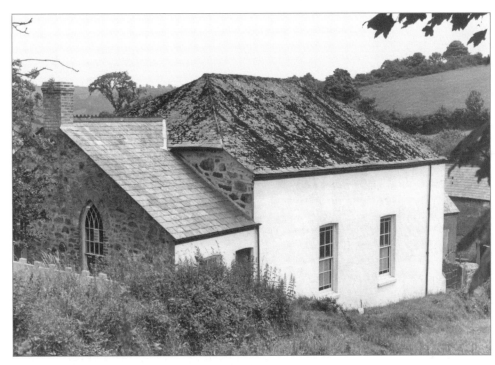

▲ **POLGOOTH,** *The Wesleyan Chapel c1955* P242005

There were few Cornish villages without a chapel; this one is typical of many, situated near the top end of old Polgooth. It has since become a house and is virtually unrecognisable today - the roof shape and the site on Chapel Hill are the main clues to its origin today.

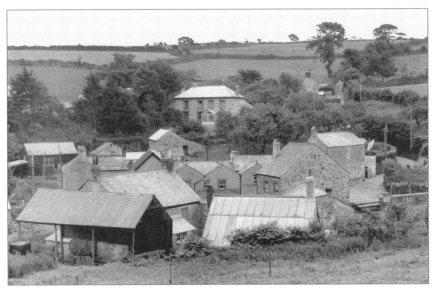

◄ **POLGOOTH**
The Village c1955
P242004

The old village is seen from near the Wesleyan chapel, looking across to Van Vean Farmhouse in the trees on the far side. Barns (foreground and left) show that this is still a farming community, but new houses have since occupied the field in the foreground.

79

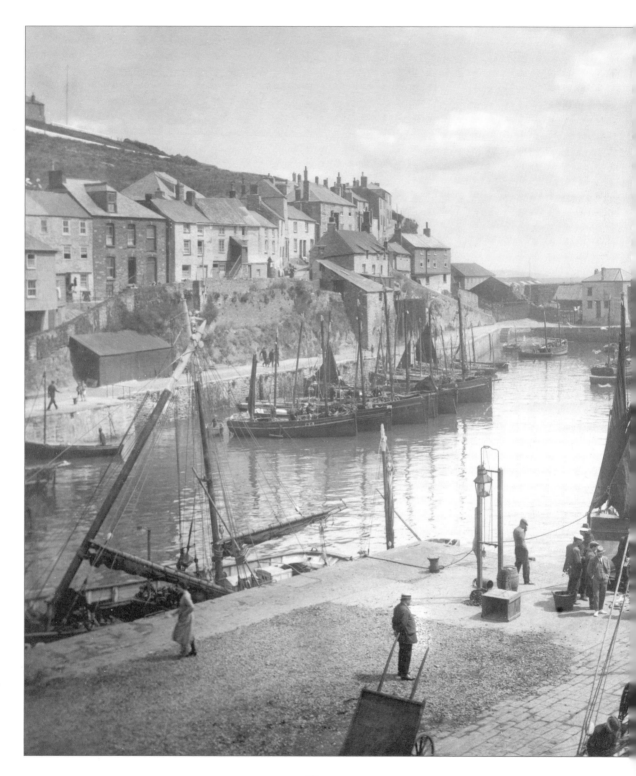

MEVAGISSEY

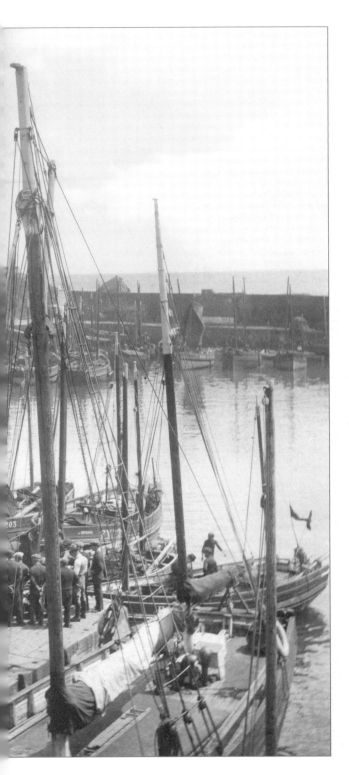

MEVAGISSEY, *The Harbour 1920* 69791

A two-masted sailing trader is moored alongside the quay in the inner harbour, while a group of men has gathered around a catch of fish. Numerous fishing boats are moored around the harbour, overlooked by a terrace of picturesque cottages.

81

▶ **MEVAGISSEY**
The Harbour
1924 76281

The full extent of Mevagissey's inner harbour is displayed, enclosed within the stone piers built in the 1770s. The sailing fishing boats are beginning to be replaced or converted to motor power at this date. Again, there is no doubt why this picturesque working fishing port became a popular destination for visitors.

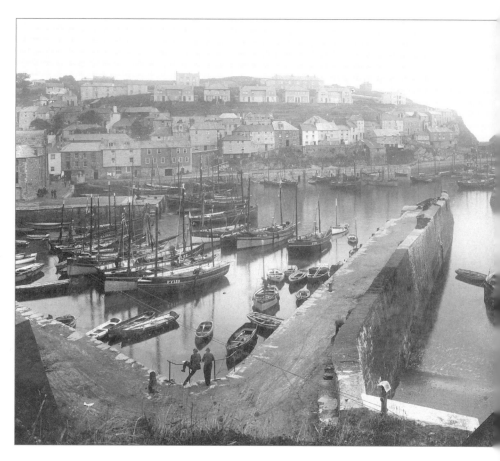

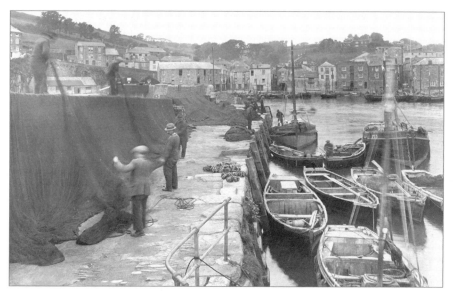

◀**MEVAGISSEY**
Mending the Nets
1924 76294

Fishermen spend much time ashore repairing equipment and making ready for the next trip to sea. Hundreds of feet of drift nets are being inspected and mended where necessary on the wall, and there is a pile of cork floats behind the men on the quay edge.

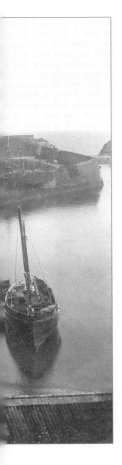

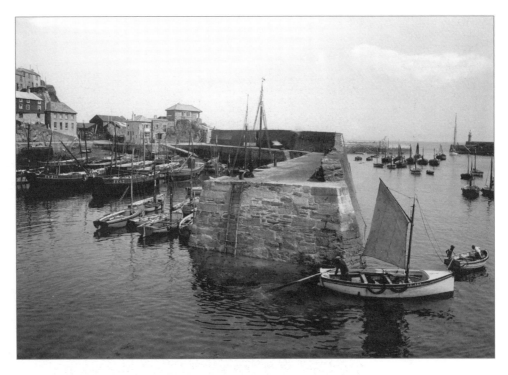

▲ **MEVAGISSEY,** *The Harbour 1935* 86545

A fisherman and two boys scull their boats around the pier of the inner harbour. This appears to be a windless day, which would no longer affect most of the larger fishing boats - they have been motorised. A large yacht has come into the outer harbour past the pierhead lighthouse (right).

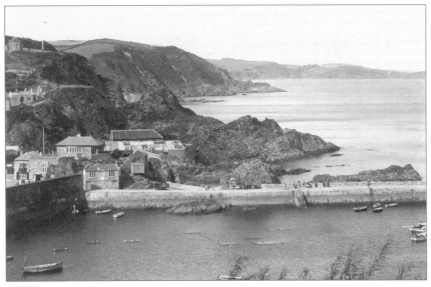

◄ **MEVAGISSEY**
The Quay and the Cliffs c1955 M68502

The north breakwater which enclosed the outer harbour in the 1890s also serves as a promenade for visitors. The harbour office (left) stands where the breakwater meets the wall of the 18th-century pier. Pentewan is hidden behind Penare Point, but Trenarren nestles in the cleft on the far side of Mevagissey Bay.

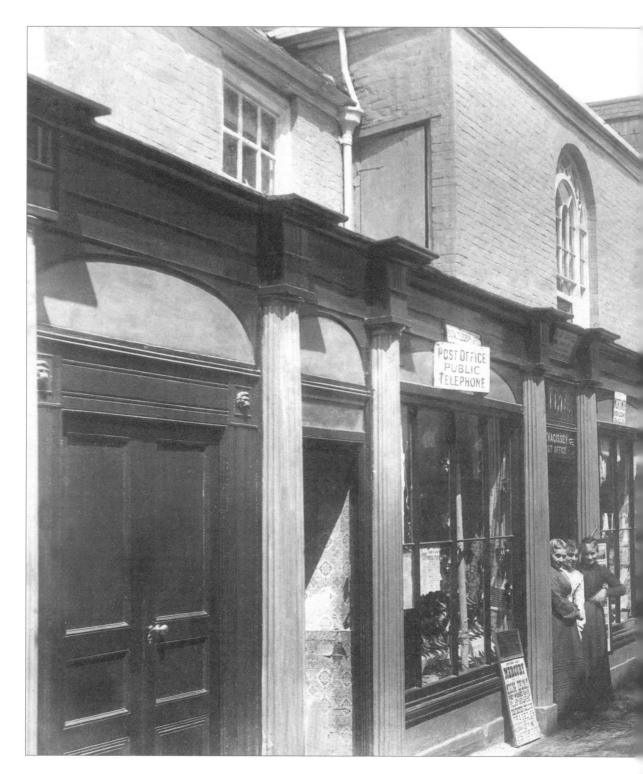

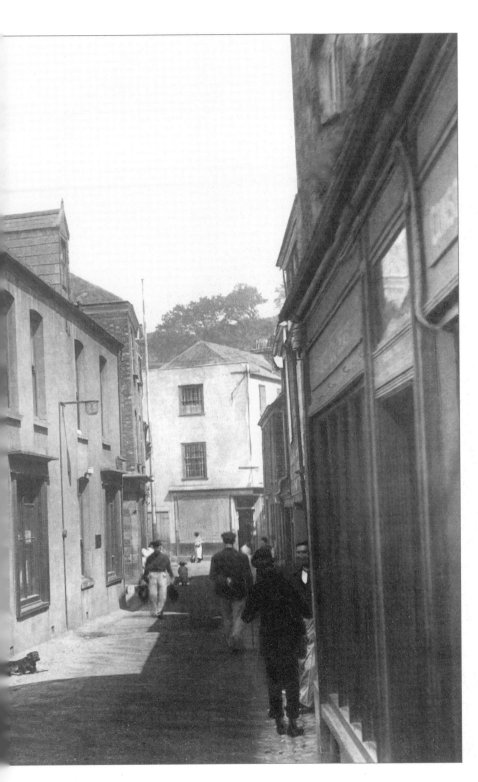

MEVAGISSEY
Fore Street, the Post Office 1904 52252

Girls, perhaps the shop assistants, crowd in the doorway of the post office, while at least one fisherman is walking up Fore Street. It is hard to believe that motor vehicles pass along this charmingly narrow street today, negotiating crowds of summer visitors. The old post office has become a gift shop.

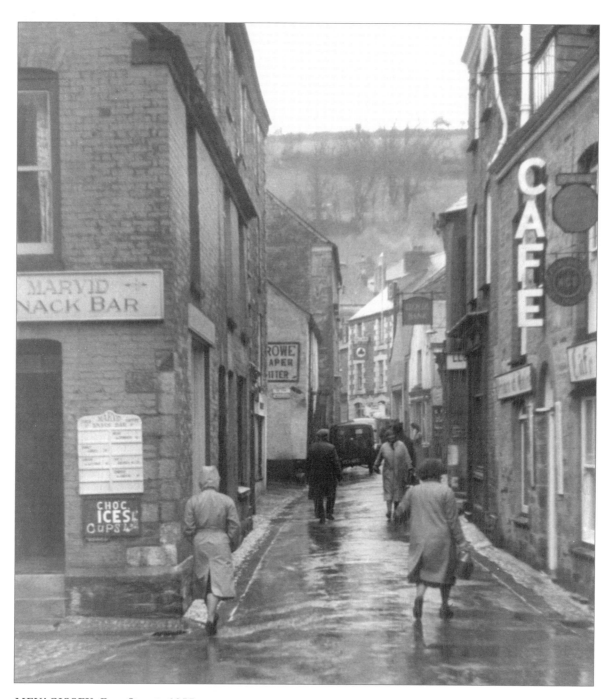

MEVAGISSEY, *Fore Street c1955* M68048

This wintry scene was taken well out of the tourist season, and is hardly an invitation for the choc ices advertised in the snack bar. Pedestrians go about their business all wrapped up in waterproofs, and the road is covered with puddles.

INDEX

NAMES OF SUBSCRIBERS

The following people have kindly supported this book by subscribing to copies before publication.

Mr & Mrs J. E. Allen, Porthpean, St Austell
Mr W. F. & Mrs E. J. Allen, St Austell
Mr H. G. & Mrs J. Ashdown, St Austell
In Loving Memory of Francis Barlow
Mrs Shirley Bate
Mr A. Bazeley, Trewoon
Mrs A. G. R. Best
Decima Bishop (nee Hooper), Par
Sallie Blackie & Family, St Austell
Jack Blake, St Austell
Ivor & Susan Bone
Veronica Borman
Sally Bourton with love, Marie
Mrs Lorna Bradfield (nee Trevan)
Mr & Mrs P. A. Bunning
In Memory of Carol Burt
Mike & Cynthia Carpenter, July 21st 2001
In Memory of Ben Carwithen
Glen & Jen Carwithen
Ann (in memory) & John Chiswell of
 St Blazey
Susan Clark, Par, St Austell
Marion Clarke, St Austell
Mrs M. E. R. Clayden, Holmbush, St Austell
Mrs Suzanne M. Clothier (nee Clayden),
 Nailsea
Ian Collis, St Austell
Stuart Collis, St Austell
Coastguard House, Charlestown
Ivy & Ron Cook, St Austell
Phillip Cook, Par
The Crilly Family, Grays, Essex
Mike Crook, Polgooth
Ruthe & Allan Crowhurst 2004
Mr & Mrs J. Crowther, St Austell

John & Amy Crowther
Anne Cundy, Porthpean Beach
R. Curtis, R. W. Curtis, St Austell
The Dabbs Family, St Austell
The Davies Family
J. Scott Davis
Christopher John Dean
Leslie Graham Dewings
Pamela & Peter Dickin, Nanpean & Foxhole
Michael Duff, St Austell
Corinne Dunstan (nee Wilkins), St Blazey
The Edwards Family, St Blazey
Brin & Dee Edwards
Jane Edwards, Malcolm Rowe, St Austell
Fred & Shirley Elton, St Austell -
 Happy Memories
Jane Elton - Wherever you are,
 memories of home
Mark Elton - So that St Austell stays
 close to home
Robert & Shirley Evans, Pentewan
Robert Mark Evely, Polgooth
Arthur Fanning, Wadebridge
In Memory of Joyce Fice
Mike & Pauline Fieldhouse, St Austell
Stan Fisher, Tywardreath
Adrian Fitzgerald
Mrs Carol Ford
In Memory of Monica Foster, St Blazey
Andrew French, Mere, Wiltshire
Michael & Joyce Gifford
Paul Golley, St Austell
The Goss Family, St Austell
Mike Gould
Mr J. W. M. & Mrs B. M. Graham, Polpey, Par

Leonard & Muriel Gwillym, Par

David Hancock, St Austell

J. & E. Harding, St Austell; J. & I. Connell, York

A. J. & H. P. Harris, Par

A. P. Hawken

Mr C. J. & Mrs S. M. Hawken

Louis Hazeland

Mrs G. Heather, Wenmouth

R. B. Hendry, St Blazey

Mrs Valerie M. Hendy

Tim Hickling, St Austell

Christine & Neil Highet, Biscovey

The Hocking Family, St Austell

Mr T. L. & Mrs M. J. Hodge, St Austell

In memory of Doris Hooper, St Austell

Mum, 'Happy 60th', love Mark, Sharon, Jack & Emily

Margaret Hugh, Debbie, Simon, Jenny, Clinton

The Hughes Family, Perth, W/Australia

W. B. Hunkin, Mevagissey

Sara & Tom Jacobs, The Hawthorns 2004

To Jean, a reminder of your childhood, with love Mum

Mr & Mrs R. Jones, formerly of St Austell

Mrs Maureen Joy Keast, St Austell

Gladys & Bert Kennedy, Luxulyan

To Kevin, 'A Cornish boy', love Caroline

Mr R. B. W. & Mrs S. A. Killen

Ted Lawrey & Joan Towle of Par and St Austell

Jacki & Roger Lewsey, Biscovey

The Lindsey Family, Tywardreath, Par

J. M. Littleton

Mr & Mrs D. Longhurst, formerly of St Austell

The McKenzie Family, Biscovey

Mr J. H. & Mrs B. J. Manuell, St Austell

Clive Marsh of St Austell

Nigel Martin, St Austell

Harry M. May, Trenarlett, Grampound Road, Truro

The Mitchell Family, Carthew, St Austell

Florence Mitchell

Jim Mitchell

Jeremy & Debbie Mitchell, Peverell, Plymouth

The Morcom Family, St Austell

Ewan Morris, St Austell

Mr D. Neville & Mrs Y. Neville

Barry and Carole Newman

Simon, Sharon, Alice & Ashley Nicholas, St Blazey

David & Carolyn Nixon, St Austell

Joyce Nixon, St Austell

Carol Oatey, Bettws Newydd

Nigel & Eileen Oatey, Stonehaven

Nigel & Marilyn O'Brien, Carvear Moor

Mrs J. O'Sullivan

In Memory of L. M. J. Oxenham & The Oxenham Family

My darling husband J. Pascoe, a 30yr dream come true

In Memory of John Charles Pascoe, Bugle

Mr D. S. Payn

Mr William Geoffrey Pearce, St Austell

Alan & Thelma Pearson, Polgooth

In Memory of Ed & Gus Phillips & Family, St Austell

G. J. Phillips, St Austell

Bertram Lionel Phillips, Tregrehan

The Pitman Family

Maureen & Geoffrey Prettyman, Pentewan

M. J. Prophet, Par

In Memory of R. A. Pryor, St Austell

Trevor & Susan Rabey

T. L. Rendell

Ms. Michelle L. Richards (nee Clayden), St Stephen

Mr J., Mrs C. & Miss K. Rickard, St Austell

Mr R. H., Mrs C. M. A. & Miss T. Roach, Trevarno, Par

Elsie Rollings, St Blazey

Michael, Carol & John Romaines, Par

In Memory of Don Rosevear, for his
 Grandchildren
Eve Ross, Tywardreath
Mrs P. A. Rowe
Keith John Rule with love Marie
Bob Rundle
C. S. & M. J. Russell, Par
Dennis W. Sandy, St Blazey
Shaun, Claire, Max, Charley: Your home in
 times past
Antonia Shields
Mr & Mrs Richard Silverlock, St Austell
Simon, Our 'Seaspray' Honeymoon 10.7.99,
 love Claire
Mr H. & Mrs T. I. Sleep, St Blazey
Gillian Smith (nee Hooper), Par
Mr T. C. & Mrs M. E. Smith, St Blazey
Henry Smith, St Austell
Mr & Mrs N. A. Spencer
Trevor J. B. Stoneman, St Austell
Mrs Mairian Stephens
Steve Stuart, St Austell
I. D. Sweet, formerly of Tywardreath
 Highway
M. N. Swiggs, St Austell
Mr Alan D. Symons, St Austell
Mrs M. Tabb, St Stephen
Mr D. L. & Mrs J. A. Taylor, St Austell
John Owen Taylor, St Austell
Pamela Ternouth
Christopher Tigg, Luxulyan
The Tregonning Family, St Austell
To Donald Trethewey, 'Happy Birthday'
 love Marian
Diana Triggs-Perry, Polgooth
Mrs V. A. Truscott
Mrs Francis Vercoe, St Austell
Sheila and John (Joe) Vivian, St Austell
Laurence Wakeley, St Austell
M. F. Waters, Barth, Cuntelleran Brewyon,
 St Austell
Mr E. C. H. Westaway, St Austell

L. & B. D. Weston & Family of St Austell
Mr Trevor Wherry, St Austell
The Wilkins Family, Tregrehan
J. L. Williams' Family, St Austell
Jean A. Woods & Terence J. Woods
Dennis Peter York

FREE PRINT OF YOUR CHOICE

Mounted Print
Overall size 14 x 11 inches (355 x 280mm)

Choose any Frith photograph in this book.
Simply complete the Voucher opposite and return it with your remittance for £2.25 (to cover postage and handling) and we will print the photograph of your choice in SEPIA (size 11 x 8 inches) and supply it in a cream mount with a burgundy rule line (overall size 14 x 11 inches).
Please note: photographs with a reference number starting with a "Z" are not Frith photographs and cannot be supplied under this offer.
Offer valid for delivery to one UK address only.

PLUS: **Order additional Mounted Prints at HALF PRICE - £7.49 each** (normally £14.99)
If you would like to order more Frith prints from this book, possibly as gifts for friends and family, you can buy them at half price (with no additional postage and handling costs).

PLUS: **Have your Mounted Prints framed**
For an extra £14.95 per print you can have your mounted print(s) framed in an elegant polished wood and gilt moulding, overall size 16 x 13 inches (no additional postage and handling required).

IMPORTANT!

These special prices are only available if you use this form to order . You must use the ORIGINAL VOUCHER on this page (no copies permitted). We can only despatch to one UK address. This offer cannot be combined with any other offer.

Send completed Voucher form to:
The Francis Frith Collection, Frith's Barn, Teffont, Salisbury, Wiltshire SP3 5QP

CHOOSE A PHOTOGRAPH FROM THIS BOOK

Voucher for *FREE* and *Reduced Price Frith Prints*

Please do not photocopy this voucher. Only the original is valid, so please fill it in, cut it out and return it to us with your order.

Picture ref no	Page no	Qty	Mounted @ £7.49	Framed + £14.95	Total Cost £
		1	Free of charge*	£	£
			£7.49	£	£
			£7.49	£	£
			£7.49	£	£
			£7.49	£	£
			£7.49	£	£

Please allow 28 days for delivery. Offer available to one UK address only

* Post & handling	£2.25
Total Order Cost	£

Title of this book .
I enclose a cheque/postal order for £
made payable to 'The Francis Frith Collection'

OR please debit my Mastercard / Visa / Maestro / Amex card, details below

Card Number

Issue No (Maestro only) Valid from (Maestro)

Expires Signature

Name Mr/Mrs/Ms .
Address .
. .
. .
. Postcode
Daytime Tel No .
Email .

Valid to 31/12/07

Would you like to find out more about Francis Frith?

We have recently recruited some entertaining speakers who are happy to visit local groups, clubs and societies to give an illustrated talk documenting Frith's travels and photographs. If you are a member of such a group and are interested in hosting a presentation, we would love to hear from you.

Our speakers bring with them a small selection of our local town and county books, together with sample prints. They are happy to take orders. A small proportion of the order value is donated to the group who have hosted the presentation. The talks are therefore an excellent way of fundraising for small groups and societies.

Can you help us with information about any of the Frith photographs in this book?

We are gradually compiling an historical record for each of the photographs in the Frith archive. It is always fascinating to find out the names of the people shown in the pictures, as well as insights into the shops, buildings and other features depicted.

If you recognize anyone in the photographs in this book, or if you have information not already included in the author's caption, do let us know. We would love to hear from you, and will try to publish it in future books or articles.

Our production team

Frith books are produced by a small dedicated team at offices in the converted Grade II listed 18th-century barn at Teffont near Salisbury, illustrated above. Most have worked with the Frith Collection for many years. All have in common one quality: they have a passion for the Frith Collection. The team is constantly expanding, but currently includes:

Paul Baron, Phillip Brennan, Jason Buck, John Buck, Ruth Butler, Heather Crisp, David Davies, Louis du Mont, Isobel Hall, Gareth Harris, Lucy Hart, Julian Hight, Peter Horne, James Kinnear, Karen Kinnear, Tina Leary, Stuart Login, David Marsh, Lesley-Ann Millard, Sue Molloy, Glenda Morgan, Wayne Morgan, Sarah Roberts, Kate Rotondetto, Dean Scource, Eliza Sackett, Terence Sackett, Sandra Sampson, Adrian Sanders, Sandra Sanger, Jan Scrivens, Julia Skinner, David Smith, Miles Smith, Lewis Taylor, Shelley Tolcher, Lorraine Tuck, Amanita Wainwright and Ricky Williams.

Free Print – see overleaf